TURNER'S PAINTING TECHNIQUES

JOYCE TOWNSEND

Turner's Painting Techniques

TATE PUBLISHING

cover:
'Turner on Varnishing Day' by S.W. Parrott
(Ruskin Gallery, Collection of The Guild of
St George, Sheffield)

ISBN 1 85437 202 5

Designed by Caroline Johnston
Published by Tate Gallery Publishing, Millbank, London SW1 4RG
© Tate Gallery 1993 2nd Edition 1996 All rights reserved
Typeset in Baskerville by Status Graphics
and Tate Gallery Publications, London
Printed in Great Britain by the Cambridge University Press

Contents

Foreword

This book was first printed as a catalogue to accompany the Tate Gallery exhibition *Turner's Painting Techniques* held in 1993. It developed from my study of a representative selection from the three hundred paintings and over twenty thousand watercolours and sketchbook pages in the Turner Bequest at the Tate Gallery. Turner was the obvious choice for the Tate's first detailed technical study, partly on account of his importance in British art, but also because earlier investigations at the Tate had shown that such a study would be rewarding. The project was proposed by Stephen Hackney, Head of Conservation Research, and was carried out within the Conservation Department, generously supported by a four-year research grant from the Leverhulme Trust. This enabled the Tate to establish a conservation science laboratory to undertake technical examination and analysis of paintings as well as studies of conservation processes. The materials and techniques of artists of the eighteenth to the twentieth centuries are being studied. Today, the laboratory is run by the author, and has a small staff, and some research interns.

This second edition of *Turner's Painting Techniques* includes a sixth chapter which summarises the results of research into Turner's materials since the publication of the first edition. More recent, related publications on the subject are cited in the notes.

In relation to the original Turner research, I must acknowledge the support and enthusiasm given to me by all members of the Conservation and Collection Services Department at the Tate Gallery. In particular, Stephen Hackney, Rica Jones, Roy Perry, Anna Southall and Kasia Szeleynski suggested useful areas of study and sources of information, generously shared their own research and observations, and have discussed past conservation treatments and the significance of the findings of my research. All of them, and Tom Learner, the second conservation scientist at the Tate Gallery, continue to provide support and practical knowledge. The then curators of the Turner collection and Cecilia Powell provided help and information on their research in progress. David Brown, Stephen Hackney and Andrew Wilton made helpful comments on the catalogue text. The Tate's photographers have produced illustrations of details, and carried out technical photography of many more paintings than could be included here. Andrew Wilton acted as supervisor for my doctoral research into the materials and techniques of Turner, with the late Gerry Hedley and subsequently Caroline Villers, both of the Department of Conservation and Technology, Courtauld Institute of Art, University of London. Peter Bower, Gillian Forrester and Ian Warrell have worked with me on more recent examinations of Turner works on paper.

Leslie Carlyle of the Canadian Conservation Institute and Sarah Cove, London, were carrying out research into nineteenth-century artists' materials and techniques at the same time, and enthusiastically discussed findings and shared unpublished

results. The Scientific Department of the National Gallery, London, provided to the Tate some analytical and library facilities, not then available elsewhere, and I am grateful to Aviva Burnstock (now at the Courtauld Institute), Jo Kirby, John Mills, Ashok Roy and especially Jennifer Pilc and Raymond White, who carried out medium analysis with gas chromatography.

Many people, then and more recently, also gave me access to their analytical equipment, provided reference samples, so necessary to analysis, or arranged for access to paintings in their collection: Marion Barclay, Shelley Bennett, Alan Brooker, John Dick, Susannah Edmunds, Owen Facey, Colin Flint, Brian Gilmour, Helen Glanville, Lorna Green, Jane Heathcock, Norma Johnson, Mark Leonard, Brian Kennedy, Alec Kidson, Kevin Knight, Graham Martin, Kristine Moore, Marianne Odlyha, Frank Placido, Boris Pretzel, Anita Quye, David Rainford, Jennie Richenburg, Jennifer Riddell and others, Alan Strawn, Norman Tennent, Paul Turner, Helen Valentine, and Paul Wilthew. For more recent studies, Jaap Boon and Jos Pureveen of the FOM Institute for Atomic and Molecular Physics, Amsterdam, have provided invaluable advice, analyses and equipment. The FOM Institute, Birkbeck College, University of London (Marianne Odlyha) and the Tate Gallery now collaborate on a number of studies of artists' materials, all of them inspired by the complex materials found to have been used by Turner.

Joyce Townsend
September 1995

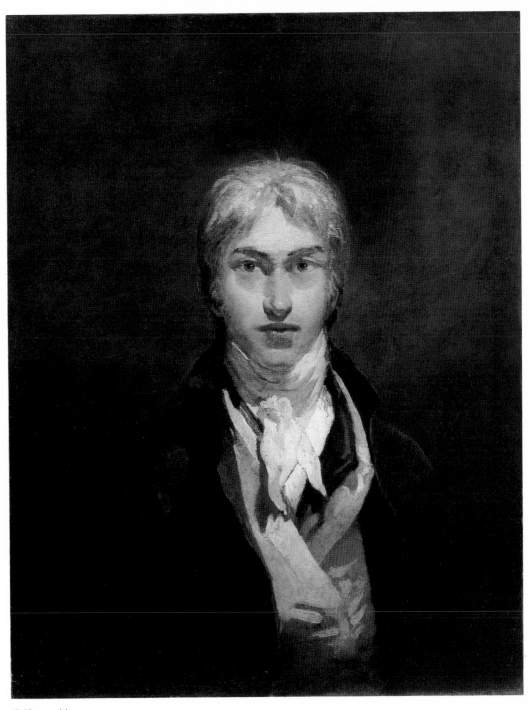

'Self-portrait' *c.*1799

Editorial Note

Full details of the illustrations are given on pages 82–4. An asterisk indicates that the work appeared in the exhibition *Turner's Painting Techniques* which was held at the Tate Gallery in 1993, when the first edition of this book was published.

Abbreviations

B&J Martin Butlin and Evelyn Joll, *The Paintings of J.M.W. Turner*, 2 vols., revised ed. 1984

TB A.J. Finberg, *A Complete Inventory of the Drawings of the Turner Bequest*, 2 vols., 1909

Introduction

Technical examination provides details of the artistic process which are rarely visible to the casual observer, and which natural deterioration and early restoration have blurred or even hidden. Much information is concealed from the gallery viewer by thick, yellowed varnish, and its recovery enables us to imagine the works as the artist saw them, to share in his doubts and improvisations during the painting process, and to read the meaning of the painting, in some cases lost to all but the artist's generation. It was one aim of this study to quantify changes in the appearance of Turner's paintings, and to discover which ones have not altered greatly. Twentieth-century criticism views Turner's oeuvre as an illustration of continued development in both oil and watercolour medium, culminating in works which required a lifetime's observation before they could be expressed effectively, and as a natural evolution which time and circumstances denied to other, shorter-lived, artists. A study of his working methods can only add to the admiration felt by viewers of these works.

That Turner's methods were innovative was noted while he was finishing paintings during the Varnishing Days at the Royal Academy, yet few knew dur-

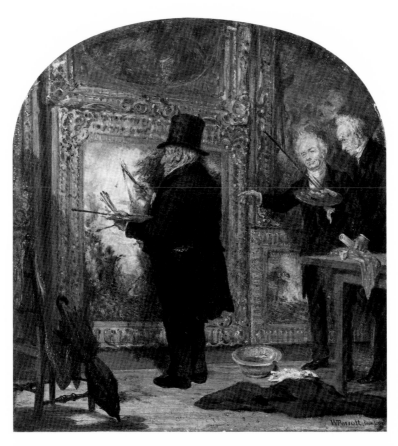

fig.1 S.W. Parrott, 'Turner on Varnishing Day', c.1846

ing his own lifetime what his materials were (fig.1). He disliked being overlooked while he worked, and kept few notes. Fortunately, a few of his friends and contemporaries did, and these writings have been assessed for accuracy, and mined for information which the paintings themselves could not reveal.

Turner's earliest practice was in 'watercolour drawing', when he copied architectural drawings, and painted landscapes for sale in his father's shop.[1] In his later teens, he attended drawing classes at the Royal Academy, sold watercolours, gave drawing lessons,[2] and is now thought to have worked as a theatrical scene painter.[3] Thus, he gained experience in a variety of media, and worked on both large and small scales. He turned to oil painting in his very early twenties, as one means of gaining a professional standing then denied to painters in watercolour, and was elected to full membership of the Royal Academy of Arts at the early age of twenty-seven, in 1802. He would have had to glean ideas on painting processes from artists' manuals or fellow artists, by studying the works of old masters, and experimenting with materials. Turner the Academician exhibited in oil almost every year of his life thereafter, and also produced many watercolours, as commissions and for sale, for reproduction as engravings, and as illustrations to books of poetry,[4] European scenery and travel, and popular annuals.[5]

One expects his earliest technical innovations to appear in watercolour first, then oil, and that his evolving colour effects in oils, throughout his life, will have a stronger relation to watercolour techniques than those of other artists. Thus, there is likely to be a greater transfer of materials, albeit unsuitable ones, from one medium to the other than was conventional at the time. Of course, Turner himself was the artist who made the greatest advances in the use of watercolour as an expressive medium, and beyond a certain period his innovations in oil and watercolour run in parallel, interacting with each other to push his portrayals of light and atmosphere to new extremes of realism (or, to his contemporary critics, beyond realism and thoroughly into nonsense, before his life was two-thirds run). Rather little has been written on Turner's painting techniques, particularly in oil medium. Ruskin[6] wrote at great length in *Modern Painters* on the 'truth of representation' of Turner's watercolours, but lamented his poor technique. In fact he knew Turner only for the last decade of his life. The earliest biographer Thornbury[7] and the more authoritative Finberg[8] were not contemporaries either, though Thornbury was able to meet many persons who had known Turner in his later years. Most recent work has concentrated on Turner's technique in watercolours[9] or has discussed only materials[10] or techniques,[11] but not the relationship between them.

For this study, over fifty paintings, two hundred watercolours and a range of sketchbooks have been examined, and analysed to various degrees. Oil paintings lend themselves more to analysis which involves sampling: they are large, and the edges are frequently damaged already by framing and early conservation treatments, whereas only tiny samples, much smaller than a pin-head, can be taken from the centre of oil paintings or small works on paper. These can yield useful information in spite of their microscopical size. The methods of examination and

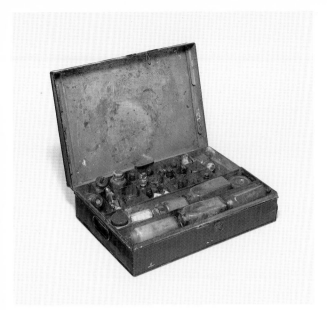

fig.2 J.M.W. Turner's box of
oil paints and pigments,
found in his studio after his
death

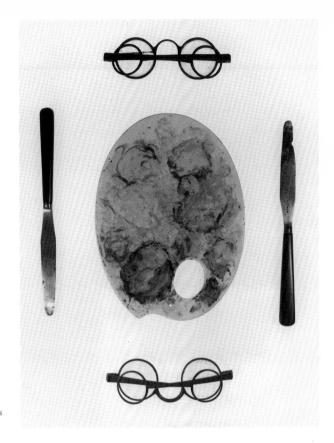

fig.3 One of J.M.W. Turner's
watercolour palettes

analysis used are being discussed in other publications.[12] They included micro-
scopical examination and appropriate imaging techniques such as x-radiography,
ultraviolet and infrared examination, with analysis by methods already in use for
the study of artists' materials, such as optical microscopy, energy-dispersive x-ray
analysis and gas chromatography, and the application of other methods selected
in the light of information obtained from these techniques. The study was
augmented by analysis of samples from his surviving paint, media and palettes
(figs.2–3), and the large body of observations, and the small number of analyses,
available in conservation records at the Tate Gallery.

The conservation of Turner's paintings, from the cleaning of surface dirt,
through varnish removal, to treatments to strengthen deteriorated canvas sup-
ports, is very hazardous, due to the varied and sometimes extreme solubility and
temperature sensitivity of his paint. Valuable information for the conservators of
Turner's works has been gained from this research. Also, his work can be related
more surely to that of other artists, and to recommended practices of his era,
many of which also led to paintings whose appearance altered drastically with
time, and which are very difficult to treat in the conservation studio. The popu-
lar idea that he knew that his materials or methods were unsound, yet made no
alterations in them, has been re-evaluated. Information on the evolution of Turn-
er's techniques has helped to date or authenticate problematic works.[13] Many of
these points can be made regarding watercolours too.

CHAPTER I

Painting Techniques

INTRODUCTION

In order to appreciate how radical was Turner's approach to painting, it is necessary to know how different subjects, sizes and media were viewed at the time, and how his predecessors and contemporaries created a work for display and sale to collectors and connoisseurs. Turner, though he lived and worked in the first half of the nineteenth century, was born in 1775, and one must look to the eighteenth century for the ideas which shaped his attitudes. Landscape painting was then held in lower esteem than history painting, in which classical and biblical themes, very familiar to the educated collector, were displayed. Such prestigious images were expensive, sought by wealthy individuals to augment collections formed over generations in many cases, and were of large dimensions. Turner was in fact rather further removed from the patron class, by birth and education, than some of his fellow-artists, and acquired for himself the elements (only) of a liberal education. Classical and biblical references abound in his works, not always correctly understood by the artist, and Turner utilised the sister art of poetry (both his own verses and others') in the titles and descriptions of his exhibited works.[1] Notwithstanding his humble origins, he aspired to 'high art' from a very early age.

Turner taught himself to paint, first in watercolour, a medium never regarded as high art, and then in oil. This was not a unique disadvantage, however: painting methods as such were not taught when Turner was young. The then newly formed Royal Academy of Arts[2] taught only drawing of classical and antique subjects. Artists had to consult books, observe and copy from the old masters, or consult other artists or the suppliers of their materials for information. Turner was fortunate in that his father lived in the area of London where artists' colourmen, engravers, and other such useful contacts were to be found. Those artists who were passionately committed to the creation of art, and who were not prepared to spend a great deal of time testing different methods and materials, used materials to hand, and invented their own techniques. Turner was such an artist.

PAINTING PRACTICES

For some artists, the process of painting in oil begins with an idea expressed as an outline sketch in pencil, pen, or washes of paint applied to a fairly expendable support material such as paper, and progresses to a sketch or blocking-in of the main composition, usually on a smaller scale but in similar materials to the final work. Compositional and colour relationships can then be rehearsed. The sketch on paper or the small-scale 'draft' need only suggest the final work in a superficial sense, as ideas are developed: the texture, background colour, and degree of finish of the sketch need not match the final version exactly, and it is no great loss to the artist if the sketch darkens with age in the studio, and becomes spotted with paint from other works. It serves its purpose by pointing the way towards a work more typical of the artist at that stage of his development.

Turner generally made numerous memoranda to himself in sketches in pencil or ink, annotated with the odd colour notes (see fig.4, for example), and had an excellent memory for such scenes and the lighting, atmospheric effects or weather which first drew his attention to them, without the need for coloured sketches. Later, sometimes many years later, he worked up such ideas directly on a canvas or panel of a suitable size, and used the result for an exhibited painting, if it came close enough to the original conception. Turner did not let ideas go to waste either, in that he retained pencil sketches in bound sketchbooks, partly coloured sketches, a few sketches in oil applied directly to paper, and many more canvases on which he had begun to elaborate ideas in oil medium. Some of these were developed for exhibition at the Academy, while other lively compositions were not. It is hardly surprising that there is a far greater number of unfinished late oils – infirmity and finally death prevented Turner from working up many of them as he had earlier ones.

It is very rare to find a conventional oil sketch or an earlier attempt at a composition, which he then abandoned and restarted on a new support of a different

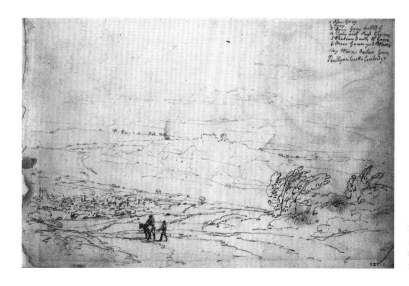

fig.4 Page from the *Smaller South Wales* sketchbook, showing Turner's colour notes, 1795

size or format. Nor did Turner ever find that his ideas outgrew the support he had begun to use, unlike Constable,[3] who rather regularly unfastened canvas from the edge of a stretcher to extend the painting surface by a centimetre or two, or even added battens and extra strips of canvas to the edge of a stretcher if the first extension was too small for his purpose.

At various times, especially at Farnley Hall where Turner was a friend of the family, and allowed his favourites to see him at work, it was noted that he would work on a group of watercolours or paintings together, using precisely the same materials for all.[4] This is noticeable in numerous groups of works on paper, and is most obvious in the series of watercolour and gouache sketches he produced at Petworth House. Series of oil sketches throughout his life very obviously include the same materials. Turner was seen working on four paintings, one of which became his last exhibit at the Royal Academy,[5] by applying the same brushload of paint to each in turn. This practice amply justifies the assumption that materials and techniques found in one painting are common to others of the same date.

In general Turner painted at home, using different rooms according to the season, to obtain suitable lighting,[6] but usually in a room which 'had been originally the drawing-room, and had a good north light, with two windows'.[7] He used the same palette and pocketbook of watercolours over many years, and latterly had a round table with a raised box of several compartments in the centre, used for keeping brushes and pigments in, according to his friend Trimmer.[8] (Trimmer appears to have been a more reliable witness than some artists who saw Turner working only occasionally during the Varnishing Days.) No descriptions of his easel have been found, and it is probable that his father built them. Three of Turner's Petworth sketches depict a tall tripod easel, capable of holding a large canvas.[9]

One sketching board has survived in the Turner Bequest – the reverse side of a panel used for an unfinished painting.[10] Paper was glued to it, not taped or pinned, and torn off hurriedly after watercolour paint had been applied (fig.5). In

fig.5 Reverse of 'George IV's Departure from the "Royal George", 1822', used as a sketching board for watercolour painting

his middle years, Turner had a series of small drawing boards with handles on the reverse, so that each sheet could be plunged into water in turn, and kept wet as he painted it.[11] This was not a practical method for paper bound into sketchbooks, obviously!

SUPPORTS AND PRIMINGS

Studies have already been made of the papers which Turner used for sketches and finished watercolours.[12] Artists were obliged to use writing or wrapping paper, since paper was not produced specifically for artists' use until later in the nineteenth century. There is evidence that Turner bought a variety of papers, well-sized to render them strong, and capable of withstanding vigorous brushwork. There was a tremendous range of paper texture, shade, and degree of absorbency available at the time, in contrast to the present day. Analytical evidence points to glue sizing – a standard method, whatever the intended use for the paper. Turner almost invariably applied watercolour directly to the paper, without using an oil priming to give the paper less absorbancy. In the earlier decades, he applied coloured washes to paper, some of which he then had bound into sketchbooks. The wash could then serve either as a mid tone, as in the charming 'Study of Pigs' and a cat in the *Studies near Brighton* sketchbook (fig.6), or as an integral part of the study, for example in 'Village with Cloud' from the *Grenoble* sketchbook (fig.7).

It was possible to buy artists' quality canvas in a range of standard sizes, with or without a priming (the surface for painting upon). Some such canvases were fastened to a strainer (a support framework of fixed dimensions) or a stretcher (a support frame with mortice and tenon joints which could be hammered out with 'keys', to alter the tension in the canvas). Stretchers could be bought ready for use, or ready for priming, from artists' colourmen. Panels, ready-primed for painting, were also available.[13] Artists' manuals written before or at the turn of the eighteenth century tended to denigrate ready-prepared primings, and to offer recipes for the artist to use.[14] Such home-prepared primings were obviously cheaper.

Turner's father acted as his studio assistant, and the meanness of both father and son is well known, though doubtless exaggerated by contemporaries. In the early years, many of Turner's paintings not only have home-prepared primings, but also homemade stretchers with the diagonal cross-members generally found in the eighteenth century, or else their supports are panels of wood cut and used for quite another purpose. The few identifiable purchased canvases came from J. Middleton and Matley of Long Acre during Turner senior's lifetime. Some panel supports, for example 'The Garreteer's Petition' (fig.33 on p.42) retain paint and varnish layers, and reinforcing strips: together these suggest that the panels came from coach bodies,[15] and might have been obtained as lumber. (After Turner's death, much of his furniture and house contents were listed in the inventory as lumber.)[16] Two works painted at Petworth[17] have panel supports strongly sug-

fig.6 'Study of Pigs' *(Studies near Brighton* sketchbook) 1796*

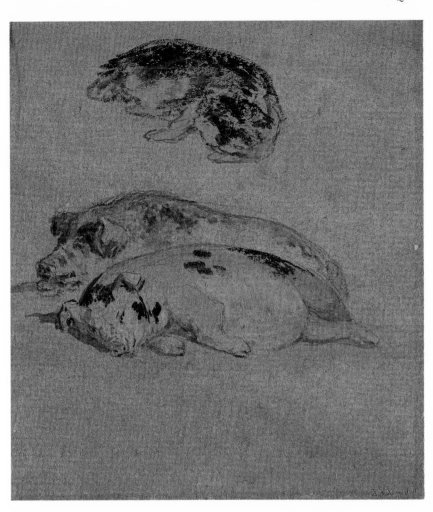

fig.7 'Village with Cloud' 1802*

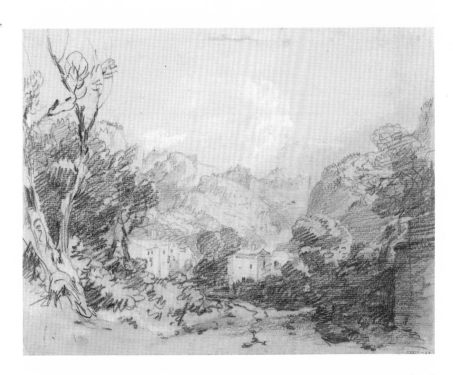

gestive of cupboard doors,[18] and another Petworth subject was painted over an unrelated image which had served its purpose[19]: expediency played a strong part in his choice of supports. For painting, the panels were clamped at the sides in a frame which accommodated a wide range of panel dimensions, and supported them along the lower edge. No descriptions of such a frame have come to light: possibly Turner's father constructed it.

It was only after his father's death in 1829, aged eighty-four, that Turner bought ready-stretched, ready-primed canvases which can be identified on occasion by the stamp of the colourman, and abandoned the home-primed ones after he had used up the last of them over the following few years. Thereafter, he bought one type consistently (Brown's), and a very few from J. Sherborn of Oxford Street, who supplied some of his watercolour blocks, or Roberson and Miller of Long Acre. Brown of High Holborn supplied canvases with a double priming of lead white and chalk in oil, separated by a size layer but not sized on the surface, stretched and tacked to the sides of the nineteenth-century stretcher style still used today (with a vertical member, and then a horizontal one slotted in, for larger canvases), and protected at the back with another primed canvas fixed to the sides of the stretcher with glue. Interestingly, the dimensions Turner used most frequently, two by three feet and three by four feet, were not standard for the period,[20] which suggests that the whole support may have been made to Turner's orders, and eventually sold to other artists too. When Turner was travelling to Italy in 1828 he wrote to Charles Eastlake for 'the best of all possible grounds and canvass' (*sic*) of specified dimensions, then muted his request to 'order me … whatever may be … got ready that you think right'.[21] Two of the Roman paintings have exactly these quoted dimensions, and all have coarse canvas, not of artists' quality, fastened with 'sprigs' instead of the usual tacks to crude stretchers (fig.8). Turner's largest compositions could not be accommodated on artists' quality canvas, and he sometimes resorted to coarsely woven sacking-type material of the req-

fig.8 'Sprigs' used to fasten canvas to the stretcher of 'The Vision of Medea'

uisite size. On one occasion only, two canvases were joined, and he then painted over the horizontal seam in the middle, for 'The Goddess of Discord' (Tate Gallery N00477).

There were a few occasions in Turner's (and his father's) life where he abandoned the habit of working up a first impression, and instead embarked on a series of sketches not intended for further elaboration. On each such occasion, his choice of supports indicates an eye to economy. One series is on a group of panels of non-matching dimensions, likely to have been acquired as lumber. Another two series are on large canvases, stretched and pinned down (the holes can still be seen in a few cases) to give a series of working surfaces, and a third on supports of millboard (a cheap support sold for artists in the earlier nineteenth century), muslin, or muslin stretched over millboard. 'Guildford from the Banks of the Wey' (fig.31 on p.40) is an example from the first series, which are thought to have been painted while Turner was sailing on the Thames.[22] It is harder to envisage the practice of pinning out and painting part of a large canvas, waiting for the paint to dry (admittedly, the absorbent priming would have promoted fast drying, as discussed below), then moving on to another area. It seems to offer no advantage save that of cheapness and ease of transport once dry, and considerable problems in use.

This study has shown for the first time that absorbancy of the priming was an important aspect of Turner's technique, both for sketches and exhibited works. Since he always painted rapidly, the shorter working time afforded by an absorbent ground would not have presented him with any problems. His early experiments and notes of the 1800s led to a consistent use of primings without a coating of size to reduce oil absorption. They were often formulated to be absorbent as well. Those prepared by his father usually had a medium of whole egg, and have a rougher texture than commercially prepared ones. Constable used an egg-based priming for outdoor sketches in 1802, purchased from Middleton.[23] Most of Turner's had lead white as the principal filler, though he tried out both chalk and gypsum with the same binder. The lead/oil primings of the earlier decades were mostly commercially prepared, and had fewer size layers between applications of priming than was typical, according to writers of the time[24] and evidence from other nineteenth-century British paintings in the Tate Gallery. The commercially primed canvases from Brown of High Holborn were also fairly absorbent, as were a few primed panels which Turner used in the 1830s, having bought them from R. Davy of Newman Street as a 'genuine Flemish ground' of absorbent pipe-clay and chalk.[25] On a few occasions in the 1830s, Turner even painted directly on sized canvas – a very absorbent surface. 'Jessica' (Tate Gallery T03887) is an example of this.

The colour of the priming plays a major part in determining the luminosity of a painting, unless the paint is applied very thickly. In Turner's earliest exhibited works, the priming played little or no part in the overall tonality. 'Morning amongst the Coniston Fells, Cumberland' 1798 (fig.9) for example, has a red priming, as shown in a cross-section from the grey sky (fig.10). The oils of the first five

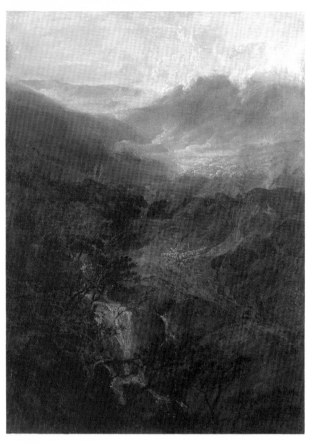

fig.9 'Morning amongst the
Coniston Fells, Cumberland',
exh.1798*

fig.10 Cross-section from the
grey sky of 'Coniston Fells'
showing the red priming

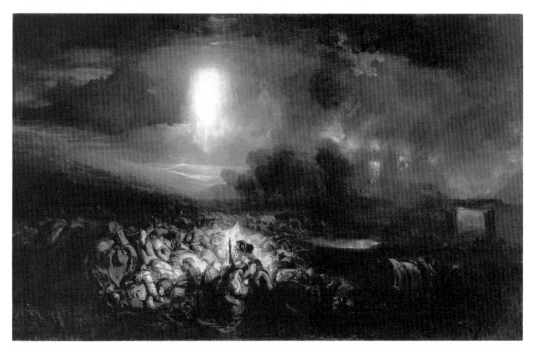

fig.11 'Field of Waterloo:
1815' exh.1818

years tend to have a creamy or pinkish priming, though sometimes a white one. Turner's grounds (whether purchased or homemade) were generally white or offwhite by 1810, whereas he was not yet using different paint from his contemporaries. For the occasional night scene such as 'Field of Waterloo: 1815' (fig.11) he (or his father) added a warm pinkish wash over a white priming. But in general he did not use a mid-toned priming as had eighteenth-century portrait painters such as Reynolds and Gainsborough,[26] nor did he leave patches of exposed priming in his exhibited works.

PAINTING IN WATERCOLOUR MEDIUM

Turner's earliest watercolours have careful pencil outlines, filled in neatly with graduated washes of watercolour on white paper, while architectural details were ruled in pencil or ink. Ruskin described the early works as conventional and carefully executed, epithets which apply remarkably little to the later ones. 'Radley Hall: South Front and East Side' of 1789, by no means the earliest work in the Turner Bequest, illustrates this (fig.12). Within a few years, the pencil marks became lighter and looser, and indicate less detail. In many pencil sketches, Turner used a hard pencil for the far distance, and a softer one for the foreground. He rapidly augmented the conventional means of producing lights by reserving areas of white paper, though he continued to use this technique when it suited his purpose, for example in 'Thames River Scene' (fig.13). He scratched out darks with a sharp point, his thumbnail, or the end of the brush, or stippled over them with a hard, dry brush (the first and last can be seen in 'Pembury Mill', fig.14) removed colour with blotting paper,[27] rubbed out areas of watercolour wash with stale bread,[28] gave texture to areas of colour with his thumb or fingers (as illustrated in the detail from 'Thames River Scene', fig.15) or washed then out with clean water

fig.12 'Radley Hall: South Front and East Side' 1789*

fig.13 'Thames River Scene'
c.1805*

fig.14 'Pembury Mill, Kent'
c.1806–7*

fig.15 Detail of 'Thames
River Scene' showing paint
worked with Turner's fingers

fig.17 'Coniston Old Man (?)'
1799–1800

fig.16 'Vale of Pickering,
Yorkshire, with Huntsmen',
?c.1815*

(as in 'Vale of Pickering, Yorkshire, with Huntsmen', fig.16). Highlights were also added in gouache, sometimes described by Ruskin or Finberg[29] as 'chalk'. Some watercolours of the 1790s have areas reserved by 'stopping-out', the application of glue size to a patch to prevent other washes covering it, until finally the resist was washed away to leave a well-defined patch of paper. This can be seen in 'Coniston Old Man (?)' (fig.17). Careful control of very wet washes gave hard edges to areas of colour, while soft edges were achieved by sponging off paint, or by moving the pigment around with a wet brush. All these methods were used as Turner's mood dictated, and generally several can be seen on one work. Not all were unique to Turner, though his skills in applying them were. Farington the diarist wrote 'Turner has no settled process but drives the colours about till he has expressed the idea in his mind'.[30]

Ruskin wrote[31] that 'Whatever material a touch may have been made with – colour, pencil or chalk – he will either use it or contradict it, but he will never repeat it ... [he never will] lay two touches over each other of the same tint'. 'Men at Windlass' (fig.43 on p.45) illustrates this to perfection. Except in the very earliest works on paper, Turner never used paint to reinforce a pencil or ink line, or shading to emphasise an outline. He did occasionally use the pencil in the manner of a watercolour wash, to give mid-toned areas with a sheen, as a contrast to matte paper or gouache, for example in 'Village with Cloud' (fig.7 on p.19) and

fig.18 'Mont Blanc from Brévant (?)' c.1836

in the well-known 'Scottish Pencils' (TB LVIII). Well before he began to exhibit oil paintings, Turner had perfected the technique of applying a few faint pencil outlines to the paper, then washing in blocks of colour, reflecting the final tones of the subject, as a means of establishing the composition. In later decades, Turner dispensed with the pencil sketch lines, and produced 'colour beginnings'.[32] Some of these have been linked to commissioned works, for example the colour study of 'Mont Blanc from Brévant (?)' (fig.18). The early colour beginnings consist of subtle variations on two colours, such as yellow and blue, which overlap to form

fig.20 'The Rigi, Last Rays' c.1842

fig.19 'Scarborough' c.1809

an optical green, as can be seen in 'Scarborough' (fig.19). In the 1830s and 1840s, when he produced an abundance of colour beginnings, Turner substituted redder ultramarine for the greener Prussian blue which he had used earlier for such works, and added a clear red (Mars red and/or vermilion in different works) for colour beginnings, and a wider palette for finished watercolours. The Swiss watercolours of the 1840s, for example 'The Rigi, Last Rays' (fig.20) illustrate the ethereal, luminous landscape which Turner could produce from a limited range of basic washes, superposed and washed out with clear water.

PAINTING IN OIL MEDIUM

Turner was adept at blocking-in a composition with washes of colour by the time he began to use oil medium, and many of his unfinished works were begun with washes of thinned oil paint applied directly to an offwhite or white priming. One of the most vivid illustrations of this technique is provided by 'Shipping at the Mouth of the Thames' (fig.21) such a promising sketch that it is hard to see why it was ever abandoned. It was begun, without drawing, with lean oil paint thinned with turpentine, premixed in a limited range of colours: yellow ochre in white (cream) for the horizon, pure umber and darker cream for the sails, dark greenish ochre (pure or mixed with black) for the principal ship, blue in white (probably cobalt blue) and pink organic in white for the sailors' costumes, and reddish ochres in white for the flesh. The horizon line, brown boats and yellow sails, sailors and some waves were sketched in initially, very quickly. The composition must have been clear in Turner's mind before he put brush to canvas, since these areas of colour interlock but do not overlap. The blocking-in would have reflect-

fig.22 'Goring Mill and Church' c.1806–7*

fig.21 'Shipping at the Mouth of the Thames' c.1806–7*

ed the final colours of the composition, had it been carried to completion. The sails above the horizon were then reinforced with less lean oil paint. Then the horizon, the principal sailing ship and the blue and white sky round it were strengthened with fairly bright opaque paint, thinned with oil, applied with a large brush. The pigments already used for the blocking-in were simply mixed with white. Then the choppy waves were painted in with long brushstrokes, some lightly impasted, largely using the premixed shades further modified with white. The boats had been keeled to meet these non-existent waves when Turner did the first lay-in. The sea in particular remains quite colourful, and would have been glazed down if the sketch had been carried further. Some of the paint is thick, almost describable as low impasto (though it is flattened by lining now), and very opaque. The rest of the sky has a very lean, non-covering slate-coloured scumble of black pigment in white.

Less commonly, Turner used pencil underdrawing, in the buildings of 'Goring Mill and Church' for example, then began to wash in clouds and water freely (fig.22). Pencil underdrawing can be discerned only in a few of the unfinished

works of the 1800s, and rarely thereafter. Charcoal sketching was rare in Turner's era. (It would have been detectable had it existed.) Sketching in white chalk over a brown wash for the landscape areas was advocated in artists' manuals of the earlier nineteenth century, but would not have been appropriate for an artist who used white primings. 'Guildford from the Banks of the Wey' (fig.31 on p.40) was painted outdoors, and once again Turner used an absorbent egg-based priming, which made the paint dry rapidly and made transport after painting, or coping with sudden adverse changes in weather, less of a problem. The paint was mixed to form just a few shades on the palette, and these were made to serve in the sketch without further modification. They were applied directly, not toned with glazing, which gives greater contrast in colour and less variation in tone than would be found in a more finished painting by Turner. The use of a green pigment here is unusual for the time – it was easier to apply rapidly than a mixed green. The medium is pure oil, applied thickly and directly.

Turner began to experiment with localised light underpainting in the earliest oils, for example 'Aeneas and the Sibyl, Lake Avernus' (fig.34 on p.42) of c.1798. This could be viewed as a development of the 'dead-colouring' used for portraits in the eighteenth century by many artists, including Hudson,[33] which consisted of a monochrome painting of lights and shade in much-thinned oil paint, the middle tones of which served for mid-tones in the finished painting, with little addition of paint. Turner's method is so closely related to his colour beginnings on paper that it is likely to have been his own invention. In later landscapes such as 'Richmond Hill with Girls Carrying Corn' (fig.23), the initial painting for skies is bright and somewhat opaque, and would have been scumbled down in tone in the finishing process. Turner's friend Trimmer said that the finished works were

fig.23 'Richmond Hill with Girls Carrying Corn' c.1819

fig.24 'Rocky Bay with Figures' *c*.1830*

of lower tone than they had been in the early stages.[34] Oil sketches not intended for finishing (as discussed earlier), for example 'Rocky Bay with Figures' (fig.24) also have skies that seem garishly bright because not glazed. The sky area intended to be yellow remained blank in the initial stages of painting, so that the pale, outlying scumbles of yellow or white would have a highly reflective white ground beneath them. The initial painting for landscapes neutralised the luminosity of the white priming.

'Story of Apollo and Daphne' (fig.25) is a highly finished, exhibited painting which illustrates Turner's whole battery of techniques, developed over a long lifetime, and a wide range of materials. It was exhibited at the Royal Academy in 1837, when Turner habitually worked on such paintings from morning to night on all three Varnishing Days. The techniques of paint application – and even compositional elements such as foreground details, water in the middle distance and the wide, receding plain – are common to several other paintings which Turner would exhibit in the following five to six years. The large size and elongated format of this painting are echoed exactly in 'The Opening of the Wallhalla' exhibited in 1843 (see pp.59–65). 'Apollo and Daphne' is a narrative painting showing several parts of the story at once: Apollo's pursuit of Daphne, encouraged by Cupid and further symbolised by the running hare, her father the river who saved her, and the ideal classical landscape (the Vale of Tempe) which she joined when transmuted into a laurel tree. It is painted on a large, single piece of

fig.25 'Story of Apollo and Daphne' exh.1837*

hardwood, primed by the colourman with an offwhite double ground of lead white and oil. The panel must have been well seasoned before use, and has survived remarkably well. The 'Wallhalla' was painted later on a matching panel, which had dirt on the priming by then.

The slightly yellow-white ground makes a considerable optical contribution to surface appearance in both works. Turner dispensed with drawing in both cases, preferring to paint directly. He evolved a way of building up the painted image in washes of thinned oil, corresponding to the final tones of the composition, over a highly reflective ground, as discussed for 'Shipping at the Mouth of the Thames'. The transparent initial lay-in for 'Apollo and Daphne' includes a bright, clear blue, touches of red and occasionally yellow as well as the traditional brown, used here for the landscape. It can be glimpsed through cracks, particularly in the middle ground and foreground. The sunny, yellow area of the sky was left blank, so that the luminosity of the priming could be utilised to the full. The brown colour beginning of the landscape, more covering than the rest, immediately created a contrast in luminosity which would be emphasised in later working-up. Turner worked on large areas at a time – the mountains, the blue sky, the shadowed foreground, the foreground details – yet returned to already worked ones when he had some paint left on the palette, and added further localised glazes or scumbles. The same pigments, and brushloads of the same types of paint medium, are found all over the surface. He tended to work up figures at a late stage, from a blob of one or two colours put in earlier, when he knew a colour contrast was required. He generally completed the yellow sky last of all. Paintings that remained on his hands, like this one, were often added to, long after the original paint had dried. In this case, Turner reinforced the line of the most distant mountains with white oil paint (fig.26) and strengthened light and already white areas of the foreground,

fig.26 Detail of the upper right of 'Story of Apollo and Daphne', showing Turner's repainting of the mountains

probably because they had sunk on drying. The repainting is crude, and may date from the end of Turner's life.

The larger paintings were necessarily done over several days, so that Turner was sometimes working into wet paint, and sometimes over partially dried paint. If the stage of drying was inconvenient, it did not deter him from painting on nonetheless. The later paint, especially when it was thinned with turpentine, often could not wet the surface properly, and dried in little islands, an effect which Turner exploited for mist, spray and trees too distant to be seen clearly. Some viewers have misinterpreted this as the application of watercolour. The more transparent areas of the foreground were built up 'optically', which is to say, with numerous thin paint layers of varied opacity and pigment loading, sometimes sandwiched with thick impasted white paint. He used similar techniques in watercolour on paper. When Turner had first begun to paint in oil, in the late 1790s, there had been great interest in megilped paint (see pp.50–1), which would hold its shape when applied thickly, yet brush out smoothly and be capable of thinning for use in glazes. By the late 1820s, Turner had settled on a formulation of wax megilp which appears in numerous paintings, including 'Apollo and Daphne'. Turner also used bitumen, sometimes combined with oil, to paint the shadows in the landscape. In 'Apollo and Daphne', the wide drying cracks, characteristic of the material, can be seen in the lower left, where it was used as an upper layer.

The unfinished Venetian scenes of 1839–45 were also built up solely with colour: there is no evidence for underdrawing. It is hard for us to imagine how they might have progressed to completion, even with similar Academy paintings available as evidence. They consist of numerous overlapping scumbles of light paint – pure white, pearly white, palest yellow, palest grey ranging up to a mid-

toned grey, and semi-scumbles of red, blue or occasionally yellow, but almost never green, of very localised extent. Ruskin wrote of such paintings, when they were being worked up in the Academy, that they were 'painted into with such rapid skill, that the artists … suspected him of having the picture finished underneath the colours he showed, and removing, instead of adding, as they watched'.[35]

Well-advanced but unfinished late works such as 'A River Seen from a Hill' (fig.27) can be seen as a development from the use of bolder colour contrasts in the 1830s and 1840s, discussed below. There is little doubt that this could have been worked up successfully during the Varnishing Days. This dazzling sketch has low impasto applied over thin paint, and assertive colour contrasts between blue sky, orange-brown land, with blank areas reserved for the water and the horizon.

fig.27 'A River Seen from a Hill' c.1840–5*

TURNER THE COLOURIST

Turner used only one 'new' technique in oils as the years progressed: we now call it simultaneous contrast. It can be seen in the unfinished 'A Lady in Van Dyck Costume' (fig.28) whose red lips are heightened with light blue, and is more subtle and harder to see by visual examination in more finished works. It is not obvious before the late 1820s. Its appearance in watercolour occurs at about the same time, and many examples can be seen in the Petworth sketches on blue paper, dating from the late 1820s.[36] The effect is well-concealed in highly finished watercolours, which are luminous without revealing obviously the techniques used to create luminosity.

Turner's knowledge of colour theories in the 1820s has been discussed elsewhere, and Turner certainly knew scientists such as Brewster, though not in that decade.[37] Turner read Goethe's *Farbenlehre* at a later date.[38] Some of his notes in the *Louvre* sketchbook of 1802 suggest that he was aware at a much earlier date of the effect that a colour has on those nearest to it and that he was analysing the works of old masters in these terms. He wrote of a Titian,[39] 'The ground pervades thro' the Portrait', and of another work,[40] 'painted upon a Brown ground inclining to a green, but when the first colours come upon it appear a purplish grey'.

Various authors were discussing complementary colours in the 1820s, and other artists such as Eugene Delacroix were using spots of colour for simultaneous contrast, almost in the manner of a divisionist technique, at that time.[41] Turner's reading must have prompted him in the same direction, independently. It has

fig.28 'A Lady in Van Dyck Costume' *c*.1830–5

been suggested[42] that Turner may consciously have exploited the contrast of primaries seen in seventeenth-century paintings at Petworth, and in the flesh tones of seventeenth-century Dutch and Flemish paintings. Chevreul first wrote (in French) on simultaneous contrast[43] in 1839. The English translation postdated Turner, and his French was not good.[44] Turner's use of simultaneous contrast, and increasing use of contrast between the complementary colours red and green from about 1830 onwards may have developed from his own ideas on colour, rather than from the application of current theories.

Turner's application of bright green and red paint in the same work predates his use of the newly manufactured pigment emerald green by a few years. Once he 'discovered' emerald green he used red/green contrasts more often. In other words, the new pigment fulfilled a need already felt by Turner.

Unfinished works of the 1830s such as 'Study for the Sack of a Great House' (formerly known as 'Interior at Petworth') (fig.29) retain some of the compositional features of his Italian paintings of the 1820s, such as the broad, warm band of transparent colour in the foreground. In this case, it is developed into a bright red band of colour which then cried out for a contrasting green. This contrast of primaries can be seen in the Petworth sketches, and thereafter, for example in very late works such as 'The Hero of a Hundred Fights' (fig.38 on p.43). Such contrasts were developed to the full with thick, opaque paint containing some lead white to give increased opacity and lightness to highly coloured pigments such as Mars red, vermilion, emerald green and viridian. One commentator[45] said that Turner introduced green cabbages into that painting to contrast with the red of the furnace. By this stage of the painting, the optical contribution of the ground mattered not at all, beneath such covering layers, and Turner's use of heavy impasto allowed him to paint over an earlier, predominantly brown, subject.

fig.30 'Modern Italy: The Pifferari' exh.1838

fig.29 'Study for the Sack of a Great House' *c.1830*

Many paintings of the 1830s are 'whiter' than these, since Turner explored different colour contrasts. For example, 'Modern Italy: The Pifferari' (fig.30) had mainly blue/yellow contrasts, and 'Waves Breaking against the Wind' (fig.67 on p.68) has warm/cold contrasts of yellow and grey. Chrome yellows, synthetic ultramarine and cobalt blue were available to Turner long before he used strong yellow/blue contrasts. In other words, the development was Turner's own, and did not follow immediately from his acquisition of new pigments.

COMPARISON OF TECHNIQUES IN OIL AND WATERCOLOUR

The very earliest oil paintings were imitative of recent and old masters, as the very earliest watercolours had been, but Turner very quickly exploited in oil the techniques he had already developed in watercolour. The use of a light ground and paint with some transparency, mixed greens or optical greens, and working of the paint with fingers, brush end, knife, etc., have direct parallels in both media. Other techniques which make use of low tonal contrast, such as the application of paint with various degrees of opacity, occur both in oils and in gouache on

paper. The initial transfer of techniques was obviously from watercolour to oil, since Turner had ten years preliminary experience with watercolour before he exhibited oil paintings. Thereafter, he used new ideas on paint application in both media simultaneously, as he used new pigments.

The interplay between initial lay-ins in thinned, transparent oil paint and true watercolour painting is more complex. Turner's use of washed, coloured paper for sketches postdates his developing use of transparent lay-ins of colour, matching the final tones of the composition, in oil in the 1800s. They represent experiments carried out in parallel, and never led to the use of blue or grey toned primings on canvas. The coloured lay-ins on canvas led eventually to series of works in both oil and watercolour in the 1830s in which blue, yellow and pink predominate, on both paper and canvas. Such colour harmonies, like the red/green ones of c.1830 and the yellow/blue ones of the later 1830s were certainly explored on paper before and during the time he was experimenting in oil medium. Both watercolours and oils of his last decade have white primings, at least when the oils were worked on a new canvas.

Many of the paintings that Turner exhibited in his last years were reworkings of early compositions of brown landscapes or dark interiors. Such reworkings, in paint so opaque that the colour of the underlayer is irrelevant in optical terms, has no parallel in watercolour, and indeed little relation to any of Turner's earlier aims. Critics from Ruskin onwards have regarded such works slightingly, and at best have called them unrepresentative: certainly they are so altered by time and inappropriate early conservation treatments that it is difficult to pass fair judgement on them now.

There is a direct parallel in Turner's use of glazes and scumbles in oils with his earlier mastery of traditional watercolour techniques. Oil medium made possible vastly greater variations in depth of colour, transparency/opacity and texture, than did watercolour.

It is more surprising that he did not try out modified oil-based media on paper, as well as aqueous medium. Yet he seems not to have used both types on the same sheet. There is no evidence that he used wax-based materials on paper either: the watercolour media which were identified were solely water-soluble gums and gelatine.

Unfinished paintings and sketches not intended for exhibition have a more matte appearance, and Turner exploited differences in pigment/medium ratio to give varied opacity and subtle optical effects which were achieved with less variation in texture than is found in exhibited works. Had they been displayed, critics of the time would have damned them for lack of finish.

The few oil paintings on paper resemble miniature oil paintings on canvas. Turner used brushes in scale with the dimensions of the support, from two-inch ones for very large sketches, to quarter-inch ones for small sketches, and even smaller ones for paper supports. The sequence of working, and techniques such as limited sky detail in the initial lay-in and working-up, and completion of the sky last of all, can be seen in oils of all sizes, regardless of support.

CHAPTER 2

Use of Pigments

TURNER'S USE OF NEWLY MANUFACTURED PIGMENTS

Turner used almost all the pigments which were first manufactured during his life-time, shortly after they became available through specialist suppliers such as George Field the colourman, whom he knew from the early 1800s. Throughout his life, Turner used traditional pigments as well, particularly the earth colours (iron oxides), which provide a wide range of shades, from yellow through warm red-browns to cool browns, and differing degrees of opacity in oil medium. He used manufactured iron oxide pigments from the earliest days too, when they were stronger in tone than the traditional materials. The widespread suspicions regard-ing the use of all such new materials and their long-term colour stability, expressed through the early and mid nineteenth century,[1] did not seem to deter Turner at all, if he found the colours and handling properties of these pigments to be use-ful in either oil or watercolour medium. George Field published *Chromatics*[2] in 1817, of which Turner said to him, 'You have not told us too much',[3] and *Chro-matography*[4] in 1835, a book which details the use of traditional and new pigments, and notes their tendency to fade, and/or incompatibility when mixed with certain materials. This information must have been available to Turner earlier than 1835, had he sought it. Anecdotal evidence[5] indicates that Turner felt that information on the stability of pigments would not be accumulated during his lifetime (which is largely true) and that stability was not his primary concern. He said once to a partner in the firm of Winsor & Newton, 'Your business Winsor is to make colours for Artists, mine is to use them'.[6]

The dates of introduction of new pigments are given in the table. The first pig-ment newly available during Turner's lifetime was cobalt blue, which he used four or five years after its introduction in France in 1802. One can speculate that he obtained it in Paris when he visited the Louvre in 1802. Its first appearance is in the skies of a series of sketches not intended for exhibition, one being 'Guildford from the Banks of the Wey' (fig.31): this is also the earliest occurrence of cobalt blue found to date in the Tate's British paintings. Turner grew bolder with sub-sequent new pigments, and used them from the first in finished paintings exhibit-ed at the Royal Academy. Oil paintings from the 1810s include areas of yellow in the sky: Turner must have been impatiently awaiting the production of still more intense yellows.

fig.31 'Guildford from the
Banks of the Wey' c.1805*

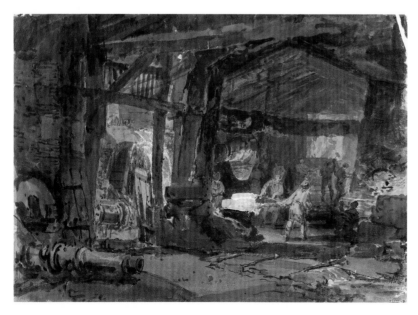

fig.32 'An Iron Foundry'
c.1797

Earliest dates of availability of manufactured pigments, compared with the first appearance of that pigment in Turner's oil paintings and works on paper. '*c*.1851' indicates that it was found in the Chelsea palette, the last one that Turner used for oil painting

PIGMENT	AVAILABLE FROM	FOUND IN OILS	FOUND ON PAPER
cobalt blue	1802 in France[7]	*c*.1806–7	1810–15
chrome yellow	1814–15[8]	exh.1814	1815–19?
pale lemon chrome	post 1814?	*c*.1822–3	1815–19
chrome orange	post 1814?	*c*.1822–3	1825–30
emerald green	discovered 1814[9]	1830s	1830s
synthetic ultramarine	1826–7[10]	*c*.1851	1828–9?
Chinese white	1834 in England[11]	1835–40	not found
viridian	1830s in Paris[12]	exh.1842	not found
barium chromate	French patent 1840s[13]	exh.1843	not found
orange vermilion	'new' in 1835[14]	exh.1843	not found
chrome scarlet	*c*.1840, Winsor & Newton[15]	*c*.1851	not found

He used chrome yellow (lead chromate) in the year of its first manufacture, 1814, and further shades of lead chromate over the following five years or so, almost certainly as they became available. Eventually he used five shades of this pigment in many paintings, but never mixed together. Similarly, Chinese white, barium chromate and chrome scarlet have been found just a few years after they first became available, and emerald green, viridian and orange vermilion quite soon after. Burnet the engraver wrote accurately of 'The extreme vividness of his colours … chrome yellow, emerald green, cobalt blue etc which none had the courage to venture upon but Turner'.[16] Synthetic ultramarine and Chinese white did not find a place in his palette after he had tried them out, however. Only three pigments available in principle to Turner have not been found: iodine scarlet, which is not easily recognisable on paper, for which its use was recommended, cadmium yellow and zinc chromate. The last two could be recognised with more certainty, had they been used. There is conflicting evidence for the availability of the last two in Turner's lifetime,[17] and his trials and adoption of all the other pigments so quickly lend weight to the view that neither was in fact available before 1850.

Areas of bright, pure pigment, applied over white oil paint or white paper for greater brilliance, figure in Turner's earlier works, for example orange and red iron oxides in watercolours from about 1795, such as 'An Iron Foundry' (fig.32) and in the fire of 'The Garreteer's Petition' (fig.33) in oil medium. When he painted 'Aeneas and the Sibyl, Lake Avernus' *c*.1798 (fig.34) he had to use orpiment and smalt, a traditional bright yellow and blue (fig.35). Within sixteen years, he

fig.33 'The Garreteer's
Petition' exh.1809*

fig.36 'Dido and Aeneas'
exh.1814

fig.34 'Aeneas and the Sibyl,
Lake Avernus' c.1798*

fig.37 'Two Women with a
Letter' c.1830*

fig.35 Paint fragment from
'Aeneas and the Sibyl, Lake
Avernus', showing smalt
(blue) and orpiment (yellow)
in lead white

fig.38 'The Hero of a Hundred Fights' *c.*1800–10, reworked and exh.1847*

had experimented with patent yellow[18] (to be seen in details of 'Dido and Aeneas', (fig.36), strontium yellow,[19] chrome yellow, cobalt blue and Scheele's green, the last of which can be seen in the trees of 'Guildford from the Banks of the Wey' (fig.31). Four shades of chrome yellow and a chrome orange can be seen by examining 'Two Women with a Letter' (fig.37), 'The Hero of a Hundred Fights' (fig.38), and 'Rouen Looking down River' (fig.39). Cobalt blue was used in 'Newcastle-on-Tyne' (fig.40). The bright green in 'Going to School' (fig.41) and 'Rouen Looking down River' is emerald green, whilst that in the later 'The Hero of a Hundred Fights' is viridian. The traditional pigment yellow ochre can be seen in 'Beaugency' (fig.42), used along with new ones.

Few pigments appear to have been adulterated or sold as mixtures, since there is little association of two or more pigments in numerous works. A mixture of vermilion and Mars red, tentatively linked to Turner's description 'vermilion red', and his contemporaries' designation 'red lead', was however used regularly in both oil and watercolour medium. A few pigments such as a purple-toned ochre (probably of the shade known as *caput mortuum*) were obtainable only intermittently.

Pigment occurrence can be used to date very sketchy works, by the yellow and orange pigments which Turner used. Analysis of pigments is more useful for clarifying the sequence of painting for reworked canvases, and for providing (sometimes) an earliest possible date for the reworking.

fig.39 'Rouen Looking down
River' *c.*1832*

fig.40 'Newcastle-on-Tyne'
*c.*1823*

fig.41 'Going to School'
*c.*1832*

USE OF WHITE

The lead white gouache in early works on paper can be seen clearly in x-radiographs, for example in 'Men at Windlass Drawing Fishing Boat out of Surf' (figs.43–4). The early *Tummel Bridge* sketchbook has at least one page entitled 'Mountains' (fig.45) whose highlights were painted in zinc white, a less toxic white pigment developed towards the end of the eighteenth century, now so transparent that it has lost most of its effect. An improved version, manufactured to overcome the failing of too great transparency and opaque enough to be used in oil, was sold from 1834.[20] Turner tried it in oil a few years after this, but seemed to find unacceptable the problems it caused by inhibiting the drying of oil paint. There is no evidence from this study that he used the new material on paper

fig.42 'Beaugency' 1826–30*

fig.43 'Men at Windlass
Drawing Fishing Boat out of
Surf' 1796–7*

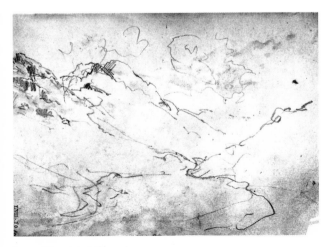

fig.45 'Mountains' (*Tummel
Bridge* sketchbook) 1801

fig.44 X-radiograph of 'Men
at Windlass'

either, preferring chalk for watercolours of the 1830s and 1840 as well as lead white. Chalk is almost transparent when applied wet, and its effect is impossible to see until it has dried, as Ruskin pointed out[21] – its use testifies to Turner's skill and confidence in the handling of paint. Chalk and magnesium carbonate are to be found among Turner's studio pigments: the latter was not commonly used for painting in the nineteenth century. (It could even have been used medicinally. Turner kept tincture of rhubarb and laudanum with his pigments,[22] and refers in his sketchbooks to laudanum as a treatment for travellers' ailments.[23]) Chalk found a limited additional use for bulking out Turner's oil-based glaze layers with a material which would be nearly invisible in oil, but which would give body to the paint, and make it less liable to flow before it dried fully.

Whites are a major and often controversial component of all Turner's oil paintings. By 1806, the critic and connoisseur Sir George Beaumont described Turner disparagingly as a 'white painter' whose works were too light, and lacked the pleasant warmth of old master paintings viewed through an accumulation of yellowed varnish and dirt. He disliked Turner's use of white, especially in seascapes, and feared that Turner would be a pernicious influence on younger artists.[24]

Impasto depends for its effect on the surface sheen and the tone of the white paint used, especially for watery and atmospheric effects. Its appearance depends too on the paint medium used, and on the proportion of pigment to medium – especially when medium-rich paint turns yellow with age. Different varieties of lead white are rather difficult to characterise in paint samples, except in terms of the proportions of basic lead carbonate (the most abundant), neutral lead carbonate, chalk and other lead compounds present. Chalk or gypsum was found as a extender in lead white paint as well as lead white primings, and would have been mixed in by some colourmen. So was barytes (barium sulphate), a dense white pigment, more usually found in Turner's later oils. Probably he knew nothing about this addition. His preference seems to have been for a lead white with about 5–10 per cent of extender added. By the standards of the time, this was a 'pure' and more expensive material. Later in life, Turner is known to have used the expensive variety of lead white known as silver white.[25] The degree of mixing and grinding of the pigment would also have affected the appearance of the paint, and gave further scope for gradations in surface texture. Ruskin described Turner as using 'a dash of pure white for his highest lights, but all the other whites are pearled down'.[26] It is quite impossible to look for such nuances in heavily varnished paintings now, or those whose surfaces have been flattened and damaged. One advanced oil sketch, 'Waves Breaking against the Wind' (fig.67 on p.68) which has never been varnished and whose surface is in excellent condition, does indeed have soft, pearly white brushstrokes for the foamy waves, and slightly starker whites in other areas. The paint consists of white not toned with any other colours, and was found to be lead white in both cases. 'A River Seen from a Hill' (fig.27 on p.34) has a selection of whites, many very bright, and the starkness of the whites in 'Venice' (fig.75 on p.75) was noted as a fault by contemporary critics.

TRANSFER OF PIGMENTS BETWEEN OIL AND WORKS ON PAPER

Turner had experimented with opaque pigments in watercolour medium from at least 1792, and had regularly used vermilion for thin washes (for example in 'Radley Hall', fig.12 on p.23), and Mars red or orange for highlights. Until about 1815, he used pigments 'conventionally' in watercolour, i.e. in transparent washes over light-toned paper. He began to use newly manufactured opaque pigments generally used for oil painting in watercolours from about 1815–19 onwards, beginning with chrome yellow in various shades, and progressing to emerald green and cobalt blue in the following decade. Chrome yellow was used extensively on white paper, quite soon after 1815, the paler shades in extended still-transparent sky washes, the brighter ones painted more thickly for details. Later, the use of very opaque pigments such as these would become nearly universal in 'watercolour' painting.

It is not always obvious from the literature of the nineteenth century whether the new organic pigments produced by Field in a range of red, purple and brown shades were intended for use in oil as well as watercolour. Turner certainly used them in both. Cochineal carmine and copper-based organic reds have been found in oils, as well as the more stable and long-accepted madder on alumina, and madders on other bases, of less certain stability. Field himself tested them in use,[27] and sought to improve their long-term stability, as well as the range and intensity of colours available, but he warned artists that some were liable to rapid fading, and were better suited to watercolour medium. Many such pigments were fine-grained and therefore particularly susceptible to fading, a fact unknown to Turner and his contemporaries. If known, this fact would have made their use in oils inadvisable.

Turner's frequent use of Prussian blue and indigo in oil, and occasional use of gamboge in oil, were not unusual for the early nineteenth century. His limited use of yellow and green lakes, and opaque greens made from mixtures of blue and yellow, in oil medium is untypical for the time, though understandable in terms of the powerful contrasts of yellow/blue and red/green he used, which required very intense, clear greens. The organic yellows and greens had too dull an appearance for his purposes, in oil. In summary, Turner's use of pigments in both media is similar, and closely related. He attempted to use most pigments in both media, when such a transfer could further his artistic aims.

THE PURCHASE OF COSTLY MATERIALS

Turner's willingness habitually to use newly available and generally expensive pigments belies allegations of meanness. In earlier years, he used Mars colours, Indian yellow and madder routinely, all of which were relatively expensive. The housekeeper who latterly prepared his palette indicated to Trimmer that Turner used cobalt blue and smalt principally,[28] and this has been corroborated in this study: these cheap and less intensely coloured blues were found in the underlayers of skies, and hence in sketches which did not evolve into finished, exhibited paintings. He used natural ultramarine in the 1830s and 1840s (at least for the upper layers of skies, where it showed to best effect) even after a much cheaper substitute was available, when the natural pigment cost '8 guineas an ounce' while the synthetic variety could be had for 'one shilling to 25 shillings the pound'.[29] (There were 21 shillings to the guinea and there are 16 ounces to the pound.) Admittedly, the synthetic one was said to last poorly in comparison to the traditional material, but this did not deter Turner in the case of other materials with desirable handling properties. His attitude to money can better be summed up as careful, and was most likely tempered during the lifetime of his father by the latter's love of avoiding expense. Particularly after his father's death, Turner favoured pigments of good quality. Nonetheless, he maintained the fiction of meanness by telling his friend Trimmer (at an unknown date), 'Cobalt is good enough for me'.[30]

CHAPTER 3

Use of Gelled Paint Media

USE OF OIL MEDIUM

It had been recommended practice throughout the eighteenth and nineteenth centuries for artists to use walnut or poppy oil[1] for white and blue areas of a composition, where severe yellowing of the oil would have an adverse effect on the surface appearance. Neither oil dries as quickly as linseed oil, nor forms such a satisfactorily tough and flexible film, though all oils have more desirable drying properties when used with lead white pigment. It is not known how many artists followed this practice in Constable's era, since few paint analyses have been published: Constable certainly used walnut oil for light colours quite regularly.[2] Later in the nineteenth century, colourmen supplied tubes of white and light colours in poppy or walnut oils, hence published analyses[3] need not reflect artists' conscious choices of oil type. Natural ageing of paints formulated with either oil would by now have rendered them equally yellow – the difference in yellowing would have been apparent only in new paint. Turner used linseed oil on most occasions, even for light areas such as skies. In a few later works he used walnut oil for such areas, whereas earlier he had used it only for oiling-out or, rarely, as a paint medium, but not especially associated with light-toned passages. From the 1820s or earlier, he used heat-treated linseed oil, more strongly drying, in most works, and also used it as a component of megilp (see below). Heat-treated oil dried faster and permitted faster working, while megilps and gelled media had a pleasing transparency for glazing, on account of the higher refractive index of the resinous component,[4] and could be used to create high or soft impasto, depending on the amount of thinner added. Some of the bladders of paint from his studio, possibly made up by Turner himself, contain heat-treated oil. Equally, the bladders could have been purchased ready-filled to Turner's specification.

IMPASTED AND TEXTURED PAINT

The earliest of Turner's oils include a thick white impasto, applied to small areas of detail such as the sheep in 'Morning amongst the Coniston Fells' (fig.9 on p.22). Such thick, buttery oil paint, brush-applied, is seen more obviously in seascapes such as 'The Shipwreck' (fig.71 on p.71). Unfortunately it is flattened by lining in every case. Experiments with impasto formulations must have occupied Turner's attention continually, as they did others of his generation.[5] 'Megilps' or 'body paint' are found in many works of the early nineteenth century. (Turner would have used both descriptions: in the language of paint technology the term is 'thixotropic paint'.) Some of Turner's experiments were not very successful. In the 1800s, Turner was using megilp made from drying oil (mostly linseed) and mastic resin, or occasionally copaiba balsam. As well as using megilp for the heavy clouds, he also used chalk as a filler, in some skies, to make the paint flow less freely.

Sketchbooks from 1808 to 1828 include various recipes, most likely given by other artists, for such media. The formulations (and spellings!) of megilp were various[6]: mastic varnish, linseed oil and a lead drier appear in the most common formulations. Other recipes for paint media included wax, white lac varnish or water as additional components. Ibbetson[7] described his own medium, consisting simply of linseed oil, mastic resin and lead acetate, and this is moderately consistent with Turner's early megilps, and Thornbury's assertion that 'everyone knew' that

fig.46 'Vision of Medea' 1828

Turner used lead acetate. Lead acetate was found in Turner's studio, but cannot be detected in Turner's paint, which invariably includes lead white in the layer of interest or an adjacent one, and confounds analysis. The artists' manual which Ibbetson published in 1803 may well be the source of a few of Turner's recipes. (They are consistent with no other manual. Turner, of course, need not have read or used any manual.) A megilped mixture generally had a strong yellow colour, its depth of tone depending on the previous heat treatment of the oil. Megilps were said to darken with time, and were suspected of causing severe and disfiguring cracking.[8] The white impasted highlights in 'Vision of Medea' (fig.46) have yellowed, to a greater extent than in most other works of the 1820s. That work was painted in Rome, possibly with locally obtained materials (the canvases he used then were Roman), which would have aged differently from Turner's usual oils.

By the 1830s and 1840s, Turner was again using stiff, pure oil impasto, applied with a palette knife, which has retained its original buttery texture and tone. The 'limp impasto' of linseed drying oil and wax (unrefined beeswax in some cases and spermaceti wax in others[9]) which Turner began to use in the later 1820s was used very frequently too. It could be mixed to form softer paint than pure oil paint, and applied with a brush or a palette knife. It sagged slightly before it dried, giving a contrast with the pure oil paint, and has not yellowed significantly. Once the formulation had been worked out, Turner used it for the rest of his life, particularly in the skies of finished paintings, for example the 'Wallhalla' (fig.57 on p.61), to be discussed later.

Most megilp formulations appear in glazes too, since oil of turpentine as well as pre-mixed megilp could be added to the oil paint on the palette. The ability of megilp to be thinned for glazes was much prized.[10] Turner found thinned wax/oil paint particularly useful for shallow water, early morning mist and distant buildings, as in the 'Wallhalla', and for foreground details, as seen in 'The Hero of a Hundred Fights' (fig.38 on p.43).

He applied impasted paint over pure oil or modified oil paint, and even over thinned megilp. In many cases it 'took' well to the still-wet surface. It was not his practice to apply a sugaring of impasto over already-dried paint: Turner's was applied as part of the painting process. Most artists of his time worked in the same way: Constable[11] was an exception when he applied his 'dewy freshness' to an otherwise-finished canvas. Most of Turner's oil sketches of the 1820s and later include impasto in the clouds, and sometimes megilp also. In highly finished paintings of the 1840s Turner sometimes applied semi-transparent glazes over the impasto of the sky, using it as a bright, opaque substrate to give sparkle to the surface.

Turner bought ready-mixed paint medium (megilp and asphaltum) from about 1835, the earliest known date[12] (because records from earlier decades have not survived) when such mixtures were first sold in pots. Later, he bought them in tubes too. He purchased a range of paints in bladders supplied by Newman the colourman, but also used dry pigment. All were found in his studio after his death.[13]

PAINT APPLICATION

Turner suited the brush size to the areas to be covered in sketches of the 1820s and later, and presumably in finished works too, though the brushwork is less evident beneath the finish. The largest brush he used for painting was roughly two inches across, whereas small sketches were worked with quarter-inch brushes, or with their point when finer detailing was required. Initial lay-ins were applied with a stiff brush, probably made of hogs' hair. Turner used softer sable or camel brushes (actually most were made from squirrel tail hairs) for finishing oil paintings.[14] Ruskin wrote[15] that on Varnishing Days Turner used short brushes held in a quill, the type used by sign-painters. Many coarse brush hairs and a few short, finer ones remain in the paint as evidence of Turner's rapid and assured working-up of compositions. The Italian sketches of 1828, and others of that decade, were blended, i.e. a 'badger' brush with a fan-shaped outline was used to mix and soften the meeting-points of adjacent brushstrokes to give a misty effect. When paint was to be blended to give a smooth, untextured surface, Turner thinned it first with turpentine and pure oil (the latter visible as blobs in cross-section, where it was not thoroughly mixed). Some applications of greatly thinned paint dried into little spots or islands with a matte surface, because too little paint medium was present to bind the pigment fully, once the thinner had evaporated.

A true scumble is a thin, opaque, non-continuous film, through which the underlying colour shows brokenly. Light scumbles over dark are commonly used, though Turner sometimes used dark scumbles over light too. He described such paint films as 'crumbling layers' in the *Studies in the Louvre* sketchbook (TB LXXII). (Some writers assume that a light layer over a dark one is a scumble, while a dark one over a light is a glaze, regardless of the transparency or otherwise of the upper layer.) As the percentage of medium relative to pigment increases (or, as the pigment loading decreases) the 'scumble' becomes less fully opaque, and many of the thin layers found in Turner's paintings are of this class.

Turner used a large palette knife to apply large-scale areas of pure oil impasto, for example the white areas of skies. Opaque layers of pale yellow were either brushed over the top, or worked into the white impasto with a stiff brush to give a more complex textured effect. The brush was used to blend the edges of the knife-applied areas into the brush-applied horizon and landscape. Sometimes thinner pure oil paint, almost a thick scumble, was given a texture which appears to have been formed by pressing in a small spade-shaped palette knife, then flicking it up rapidly. Smaller areas of impasto were flicked in with a brush, to indicate trees and other vegetation.

There is evidence that Turner worked paint with his fingers, in both water and oil media. In the case of watercolour medium he used the technique less after the 1820s. More late oil paintings show evidence of finger working than earlier ones, probably since Turner applied fewer glazes which conceal the application techniques in the later works. In paintings from the 1820s curved scratch marks are visible, apparently made by Turner's thumbnail. More than one contemporary of

Turner's noted that he kept his thumbnail long for the purpose.[16] He used the handles of brushes too, to make straighter, deeper, scratches. Works on paper were scratched with sharp points (pins?) as well as with brush handles and finger-nails.

NON-OIL MEDIA

Bitumen made an appearance perhaps as early as 1800–9, in association with copaiba balsam on occasion. Turner used it increasingly throughout the 1830s and 1840s, by which time it could be purchased ready-mixed. Bitumen has been found as the principal component of the paint medium, mixed with drying oil, and mixed with drying oil and a wax (presumably beeswax). Such a medium, naturally dark brown in colour, was very useful for painting deep, glossy shadows in landscapes. Its severe cracking and darkening in response to heating, both of which will be discussed in the next chapter, are now very noticeable and are characteristic of the material. Bitumen has caused disfiguring cracks in many nineteenth-century paintings, as will be discussed in the next section.

The writings of some of Turner's contemporaries would suggest that he used watercolour medium while he was finishing paintings on Varnishing Days,[17] though the observers who described his paint surface as comprising 'various media', including some filched from the palettes of other artists,[18] were more accurate. Some of the highly thinned paint which Turner used looks like watercolour medium, but in fact none was found – or none has survived – on any of the finished paintings examined for this study.

SOME PAINTINGS IN DETAIL

The 1820s sketches are more developed technically than were those of the previous decade, such as 'Guildford from the Banks of the Wey (fig.31 on p.40). Opaque paint was brushed directly onto the canvas of 'Between Decks' (fig.47) premixed on the palette with linseed oil. Further detail in the sea was added by applying the same paint with a palette knife. At least two sizes of brush were used. Very little of the paint was thinned with oil, as cross-sections show: Turner worked on sketches so rapidly that he did not need to increase the drying time by this means. The thick paint cannot have been thinned with turpentine either. The cream ground is visible in parts of the sea, contributing less luminosity than white grounds would. (In finished works it is concealed.) The sky is scumbled lightly over thicker white scumbling which was used to make the sky appear more luminous, and to conceal the warm priming more completely. The headland is also scumbled in, and the shapes of areas like this evolved as Turner was sketching them,

fig.47 'Between Decks' 1827*

perhaps because he had a shifting viewpoint from the sea, and made use of the best one. He used thinned oil paint to scumble in the water, and added a few blobs of brighter yellow for later development, to the sea. (In more developed works, such blobs evolved into buoys or floats.) In some of the sketches in this group, knife-applied paint was further textured by dragging a dry brush over it, for example in the glimpse of the sky of 'Between Decks'.

More subtle variations of texture were achieved in 'George IV's Departure for the "Royal George, "1822' (formerly known as 'Shipping, with a Flag') (figs.48–50) through contrast between stiff oil paint applied as low impasto with a fine, stiff brush for the foam, and megilped paint laid on with a soft, broad brush for the clouds. Scumbles were added over some of these clouds, contrasting in opacity with the thin washes, made medium-rich by the addition of oil, used to indicate the sailors. A narrow range of pigments was used: three ochres, Mars red or orange, a pink organic pigment, pale lemon chrome, smalt, black, but no green. The difference in handling and texture of paint was achieved by the addition of pure oil, turpentine or megilp to the basic colours which were already mixed on the palette. These simple additions enormously increase the range of effects which can be achieved in oil, and all were utilised in paintings worked up for exhibition too.

Bitumen-rich areas of shadowed landscape can be seen in 'Landscape: Christ and the Woman of Samaria' (fig.51). The whole foreground has a warm red appearance, in common with many of Turner's Italianate landscapes, and an underpainting in bitumen-rich paint, which tends to crack when another layer of the same material overlies it. The white goats displayed an interesting contrast in

fig.48 'George IV's
Departure from the "Royal
George", 1822' c.1825–30*

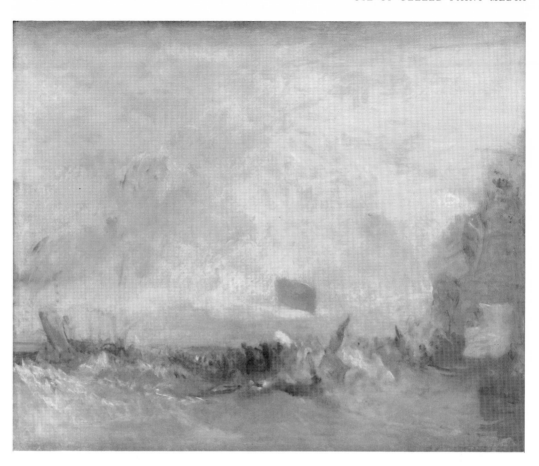

fig.49 Detail of clouds and
sky from 'George IV's
Departure from the "Royal
George", 1822'

fig.50 Detail of water and
figures from 'George IV's
Departure from the "Royal
George", 1822'

fig.51 Landscape: Christ and the Woman of Samaria' c.1825*

fig.52 Detail of the waves in 'Waves Breaking against the Wind'

fig.53 Detail of the shore in 'Waves Breaking against the Wind'

texture to the smooth, then-uncracked landscape, but now their white impasted paint is flattened. Fortunately, it retains brushmarks, and still gives a fairly convincing impression of texture.

Turner's concern in later works was to capture a particular effect of weather or lighting. 'Waves Breaking against the Wind', c.1835 (figs.52–3, fig.67 on p.68) is a more developed sketch, though it lacks the 'human interest' of an exhibited work. The sketch was begun in warm and cool greys to establish the horizon, then impasto was added for the waves, lower impasto and dry paint for the shore (more yellow than in its worked-up tone), and the yellow sky in the right portion was scumbled on, then applied in increasingly thick layers, some with a palette knife. The blue sky apparently breaking through the clouds was in fact added over the grey, as localised scumbles. The breaking wave was more yellow at first, and has been scumbled towards white before impasto for foam, and grey scumbles and black glazes for the tossed water droplets, were added by sweeping a brush over the surface so lightly that the modifying tones only made contact with the higher ridges of paint previously laid on with a dry brush. The darkest grey foam was applied in lean, unthinned paint (black and white) applied thickly. Such paint is usually mixed with pure linseed oil. The turpentine-thinned paint is underbound, and has separated on drying to form little islands of paint. This paint has been lost from other paint surfaces, where it adhered poorly to partly dried paint. The topmost glazes of Mars red, Indian red and purplish ochre have formed similar films. The scumbles used to build up the warm red shore were also applied lightly, the early lay-in being a chrome yellow shade. Successive localised scumbles, not quite as underbound as the paint used for the sky, of deep chrome yellow, Mars orange and red, black, sienna, olive-toned, brown and purplish ochres overlie it. Many of these scumbles do not extend to the edge of the canvas, an effect of rapid application which can be seen in most oil sketches. Glazes have been introduced sparingly, and the general effect is of a matte, scumbled surface. The next stage would have been scratching with a brush-end or fingernail to modify the texture, as seen in exhibited paintings.

CHAPTER 4

Finished Paintings

THE VARNISHING DAYS

There are many anecdotes of Turner at work on the three Varnishing Days before the annual Royal Academy of Arts exhibition opened to the public. The first occasion when Turner completed a painting there, by adding glazes and toning to transform it from a 'sketch' to what his contemporaries would have called a 'finished picture' may have been 1818.[1] Most descriptions refer to later decades.

Turner finished his paintings by applying scumbles, glazes and impasto, over and over, to an unfinished sketch. His glazes are very lightly pigmented, and are nearly as transparent as a layer of oil or resin applied to the surface and left to dry. They derive the great bulk of their colour now from the medium, as the deep golden tone acquired on ageing eclipses the delicate toning provided by the pigments. Mars orange occurs very commonly in toning glazes over blue water or sky, in very low pigment loading, so the original warm tone becomes intensified. Any originally blue glazes are in effect masked by the ageing of the medium.

There is certainly a wider range of pigments, and a greater number of intensely coloured ones, in exhibited paintings as compared to sketches, but there is little evidence that Turner used a distinct palette on these occasions, save for the introduction of ultramarine for blue skies. The principal difference lies in the medium, which consists of not only pure oil in the exhibited paintings, but also beeswax, mastic, heat-treated linseed oil, bitumen, and probably other waxes and resins as well. Well-advanced sketches which did not reach the Academy walls generally include some, occasionally all, of these medium modifiers, in addition to pure linseed oil medium.

It is not usually possible to tell which parts of a painting were finished on the Academy walls, and which before. More often, any major reworking involved the application of paint to most of the surface.

TURNER'S METHODS OF FINISHING

'Morning amongst the Coniston Fells, Cumberland' (fig.9 on p.22) was exhibited in 1798 and consists of thin layers of paint in which ochres and lead white predominate, applied over a priming. The paint medium is principally or entirely oil in every layer examined. These earliest paintings are among the few in Turner's oeuvre in which one can discuss 'paint layers' applied to the whole canvas. 'Dolbadern Castle, North Wales' (fig.74 on p.74), presented to the Royal Academy of Arts as Turner's diploma work in 1802, is painted with similarly substantial layers.

In all but the earliest works, the uppermost glazes and scumbles are so thin that their surface appearance is dependent on light reflected from the layers beneath, as well as on pigment content and medium colour. The appearance of such non-hiding layers is also strongly dependent on the surrounding colours and their opacity/transparency, to a greater extent than a patch of fully opaque paint would be. Oil paintings by Turner are frequently described as consisting of 'numerous glazes and scumbles over opaque bodycolour/white paint'. In many cases, the 'opaque bodycolour', often seen to be heavily brushmarked, is in fact the priming, and the entire landscape consists of the 'glazes and scumbles'. Even the initial blocking-in resembles a glaze, up to the mid-1820s, and appears to be glaze-like in works after that date, except in sketches not intended for exhibition. The topmost layers in a part-finished or fully-finished landscape are generally more glaze-like than scumble-like, and their surface, in the absence of varnish, resembles that of a watercolour wash on paper. They darkened the shadows effectively.

Shadows in the landscapes of finished paintings are always deeper and more transparent than in sketches. Throughout the nineteenth century, artists used transparent brown organic materials such as bitumen, asphaltum and Vandyke brown for transparent shadows, applying these materials as glazes, combined with oil or resinous medium. Resinous medium used instead of oil gives an especially glossy, saturated appearance to the underlying oil paint because its refractive index is high.[2] Wax added to these areas gives a matte, slightly milky appearance very appropriate to the green water in 'Van Tromp Returning after the Battle off the Dogger Bank' (figs.54–5) for example, which is coloured optically by superposed glazes, quite localised in extent, and very thin, with crisp impasto on top for the foam. It is a very noticeable feature of Turner's technique that the same pigments are used for glazes which form water, reflections, wet shores, etc. The unfortunate consequence is, that these distinct areas grow more alike as the medium yellows and darkens with age. The glazes are more numerous and varied in opacity and pigment loading where they form reflections in the water.

Turner could delineate figures, even faces, very accurately when he viewed them as an important part of the original conception of a work. However he sometimes added them to a painting at the finishing stage, simply because a spot of colour was needed at that point in the composition, to render all the other

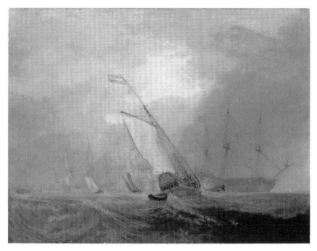

fig.54 'Van Tromp
Returning after the Battle off
the Dogger Bank', exh.1833

fig.55 Detail of the sea in
'Van Tromp'

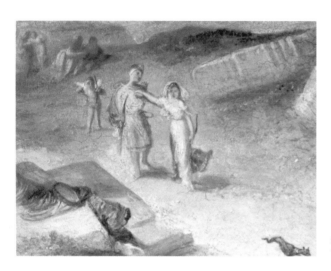

fig.56 Detail of the figures in
'Apollo and Daphne'

coloured masses most effectively. For example, this can be seen in the placing and
re-placing of the figures in 'Landscape: Christ and the Woman of Samaria' (fig.51).
In this case, the figures were applied in their final colours, and were built up with
further scumbles, after one head had been shifted, but not finished. The faces,
hands and arms, generally applied in the warm red ochres used for the sur-
rounding landscape, are very roughly coloured with a few brushstrokes, and lack
roundness or symmetry. Where the figures ought to be the focal point of a com-
position, for example in 'Apollo and Daphne' (see pp.31–3) they were begun with
a cursory application of thick white impasto, then finished at the same time as
other details. Both Apollo's and Daphne's faces are nonetheless very vague on
close viewing, yet show no evidence for damage through overcleaning (fig.56).
Turner must have spent more time on the water in the distance than on paint-
ing them.

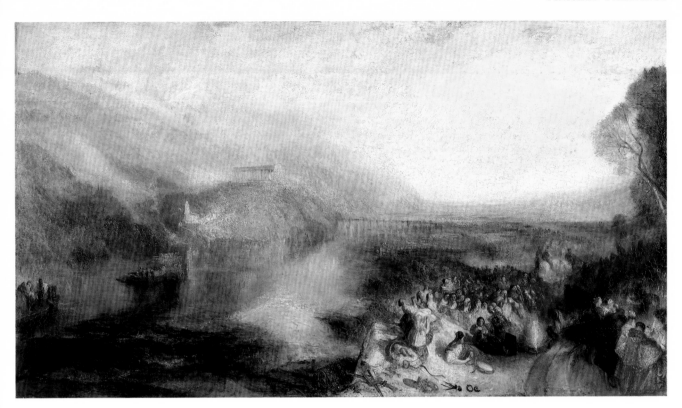

fig.57 'The Opening of the
Wallhalla' exh.1843*

The skies of most landscapes are painted thickly and opaquely over the white
priming, while the deepest blue areas have a blue underpainting. Though the
paint is heavily worked with brushes and a flat, flexible palette knife, the degree
of finishing, in the sense of glazing, is minimal in most cases. The final wet work-
ing of the sky, in medium-rich linseed oil or occasionally walnut oil, was carried
out when the main form of the landscape had been completed, and any areas of
colour for later development into figures or animals had been placed. It overlies
the finished landscape or the horizon in many paintings. Skies are always paint-
ed up to the tall trees that cut across the horizon line, with emphatic brushing of
stiff oil paint to give the effect of halation round the tree. An oil-thinned paint
medium, provided the oil added had not been heat-treated, had a long working
time before it began to dry, and new brushloads of paint could be worked in wet.
When the wet-in-wet working finally dried, it formed a single layer.

Writing about 'The Opening of the Wallhalla' (fig.57), a critic drew attention
to 'the quality of Mr Turner's colours, and his peculiar mode of applying them to
the canvass. His pigments are generally very much diluted, and seem to be laid
on the canvass, not in broad heavy flats of colour, but by a successive elaboration
of touches, each one more delicate and slightly differing in tint from its predeces-
sor … he has succeeded … in getting the atmosphere – the colour – the depth of
nature herself into his pictures.' Another said 'The picture is a whirlpool, or a
whirlpool of colours'. Turner used at least three red organic pigments, natural
ultramarine, Prussian blue, emerald green, viridian, pale lemon chrome, mid
chrome yellow, chrome orange, Mars red, Mars orange, yellow ochre, a number

of other ochres or Mars colours and bone black, quite an extensive list for one painting. The shallow water over the sandbar was built up with two blue pigments, as well as mixtures of pigments in glazes (fig.58), a green pigment and a deep golden yellow chrome one.

Extensive analysis of the paint showed that Turner used linseed oil, heat-treated (and faster-drying) oil for the sky, bitumen and oil for the shadowed landscape, pure (mastic) resin and oil/resin mixtures for localised glazes and scumbles, oil/wax dispersions (fig.59) (including beeswax and spermaceti wax) and layers of almost pure wax medium for the water, and a technique described by Ruskin and found only in finished paintings (fig.60): 'His colours were mostly in powder, and he mixed them with turpentine, sometimes with size, and water … as the grainers do … binding it in with varnish afterwards'. In this case, he used size for mixing. The technique gives a very saturated colour, and was used for especially bright areas of costume. The finishing glazes in oil medium, applied over this considerable variety of paint formulations when they were part-dried, have contracted and dried in dots. This was a problem when Turner was working on a large surface: some areas of paint which included driers would begin to form a skin on top, and could not then be safely overpainted until drying had progressed further. Turner painted on regardless however, and individual layers soon cracked (fig.61) – within days of application, according to Ruskin, who wrote, 'No picture of Turner's is seen in perfection a month after it is painted. The "Wallhalla" cracked before it had been eight days in the Academy rooms'.[3]

The sequence of thin layers varies over the whole surface, and is sometimes very complex. Shore and water are linked in tone by dark glazes with a vertical emphasis. The darkening of glazes in the foreground now presents too great a contrast between these areas and the sky, which has fewer glazes. There is evidence for palette knife application of paint in the least cracked areas, which are sky and deeper water, and shaping of the banks of mist on the left with the knife, after the paint had been applied with a brush. Since much of the paint was medium-rich and/or consisted of a dispersion of oil and wax, it has flowed after application. The steps to the Wallhalla have incised horizontal lines to emphasise form, made with the end of a brush. The vegetation below the white rocky promontory was textured with less regimented lines, the work of Turner's thumbnail. An x-radiograph of a foreground detail, and the corresponding detail on the surface (figs.62–3), shows that the lead white priming is extremely thin. The grain of the panel support shows clearly on the x-radiograph. The flesh of all the figures, and the white horses, are visible as a few deft brushstrokes, applied and modified in one sweep, and then left for further glazing. Only the yellow cloak of the woman in the foreground has any thickness of paint, and it too is built up from dabs and brushloads of paint, applied quickly, which give an incoherent image, since the glazes are not visible. The indistinct figures in the distance, which consist of semi-glazes and semi-scumbles of ochres, and large amounts of medium, scarcely show up in the x-radiograph. Even the stone figure by the fountain shows up indistinctly, since there is little lead white in its paint. The colours, scale, and the type

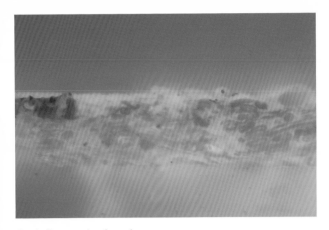

fig.58 Cross-section from the
river in the foreground of
'Wallhalla', viewed in
ultraviolet light, showing a
dispersion of wax and oil

fig.59 Another cross-section
from the river, viewed in
normal light, showing
complex layers of glazes and
scumbles used for the water

fig.60 Cross-section from a
costume in the foreground of
'Wallhalla', viewed in
normal light, showing a dry
scumble of pigment glazed
over to give the colour depth

fig.61 Cross-section from a
figure in the foreground of
'Wallhalla', viewed in
ultraviolet light, showing a
complex series of glazes and
scumbles, and a thick waxy
layer in the centre

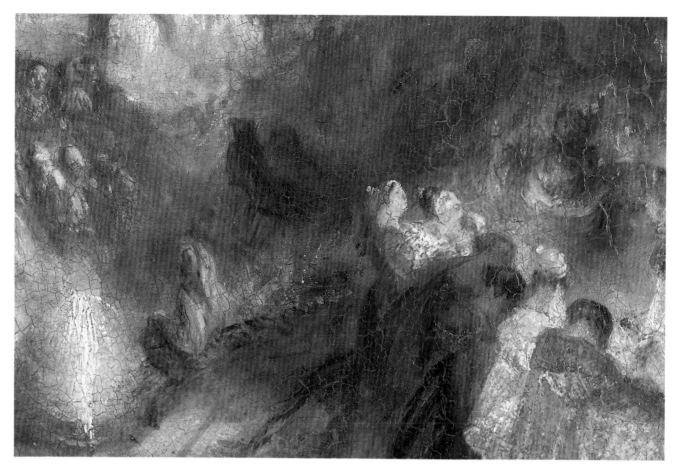

fig.62 Detail of the
foreground of 'Wallhalla'

fig.63 X-radiograph of the
same area of the foreground
of 'Wallhalla'

fig.65 Detail of the sea of
'Peace – Burial at Sea'

fig.64 'Peace – Burial at Sea'
1841 exh.1842*

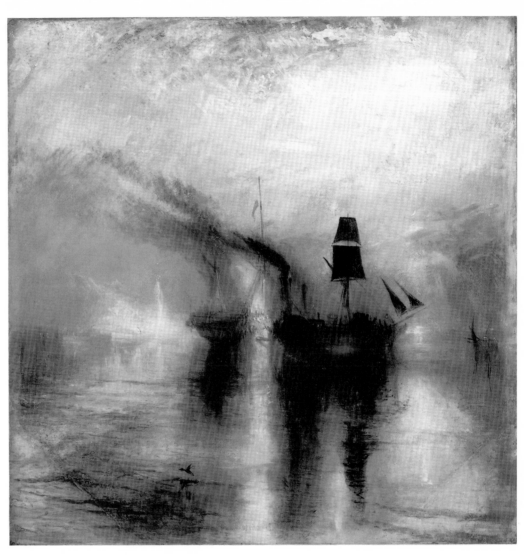

of material portrayed are very similar in other exhibited works, for example 'Apollo and Daphne' (fig.25 on p.32).

'Peace – Burial at Sea' was finished in an octagonal frame, and is now displayed with the corners visible, as an illustration of the effects of 'finishing'. It has in fact almost no glazes in the sky – it is not a morning scene, either symbolically or actually, and its sky looks particularly 'unfinished' compared to the rest of the painting, which is rich in glazes. The paint surface is in very good condition, which enables one to appreciate the 'finish' on the water (figs.64–5). 'The Angel Standing in the Sun' (Tate Gallery N00550) is comparatively free of glazes, and was ridiculed, along with others of similar appearance, when first displayed.

TURNER'S VARNISHING PRACTICES

So far as one can tell from restorers' observations in the past, Turner's earlier paintings were varnished with a mastic-like alcohol-soluble varnish, now removed in almost every case. One of Turner's surviving letters implies that he must have used a very rapidly drying varnish such as mastic in spirit. Oil/resin varnishes dried more slowly. He wrote on a Friday, 'I shall varnish it for the last time this evening, and on Saturday morning … it shall be forwarded to Oxford'.[4] Mastic was one of the standard materials of the time.[5] The exhibited paintings which he sold would likely have been given a final coat of varnish at least a year after purchase, the minimum time considered sufficient for a painting to dry in the English climate, by nineteenth-century writers.[6] At that time, the owner would have specified the varnish type, or asked another artist, or perhaps Turner himself, to apply varnish of his choice. Turner copied recipes for 'amber' varnishes, generally preferred by traditional collectors, into his sketchbooks, but it is hard to imagine that he would have applied them gladly, thereby destroying subtle colour contrasts and contrasts in opacity. They would have been appropriate only for early attempts in the style of Dutch seventeenth-century masters, which Turner painted in the 1800s. ('Amber' refers to the colour only; natural amber was not an ingredient.) So little evidence remains on the paintings or in his writings, save for Trimmer's mention of 'copal', a material of more variable quality and colour than any other used in Turner's era,[7] that one can infer nothing about Turner's later preferences regarding materials for varnishes.

It is unusual to discuss varnishing preferences at all, for an artist of the earlier nineteenth century. In most cases, one would assume that varnish was applied as soon as it was considered safe to do so, to preserve the highly glazed, finished surface of an Academician's painting. Turner's lack of finish in exhibited paintings was seen as unusual and reprehensible by his contemporaries: this lends interest to his preferences for varnishing. The sketches which have survived in good condition show us how varied Turner's paint surfaces can be, when unvarnished. A later generation of artists would exploit the contrast in appearance between dry paint and glossy varnish: Turner was aware of such optical possibilities, but did not utilise them in his Academy paintings. Perhaps the criticism of his contemporaries deterred him from this very radical procedure.

It is entirely possible that the outspoken criticism of Academicians on Varnishing Days prompted Turner to add glazes and a degree of conventional finish to his exhibited paintings, for there is much anecdotal evidence[8] that he was hurt by criticism, even when he felt it to be unjustified. The contrast between his own unfinished works and the newly varnished ones shown by other artists must have been extreme, and must have forced itself on Turner's notice every year. Extensive glazing at the time would have reduced the difference in appearance between his works and the rest, while the paint remained wet.

CHAPTER 5

Changes in Appearance with Time

TURNER'S USE OF UNSTABLE MATERIALS

It is clear that Turner used many pigments considered later in the nineteenth century to fade or darken rapidly: cochineal carmine, which he used in both oil and watercolour was known to fade by Turner's era, and many of his madders on unusual bases were found to be very fugitive when their lightfastness was tested in this century. The evidence that they have faded from the rosy clouds in landscapes (in oil) of the 1830s and 1840s is unequivocal. Examples cannot now be seen in 'The Opening of the Wallhalla' (fig.57 on p.61), but morning scenes in other paintings of similar date, for example 'Rosenau' (fig.66) exhibited two years earlier, give an idea of the earlier appearance. Close examination of 'Waves Breaking against the Wind' (fig.67) revealed a rosy sunset on the right, surviving where the frame has covered the paint at one side. Early paintings have also altered in colour, according to viewers of the nineteenth century. For example, 'Apollo and Python' (fig.68) was described as having 'gleams … of blue and gold' by Ruskin,[1] and they cannot be seen at all now.

Doubtless there have been major losses in reds in watercolour too. In sunsets and in many of Turner's atmospheric effects they are not immediately obvious.

fig.66 'Rosenau' c.1841–2

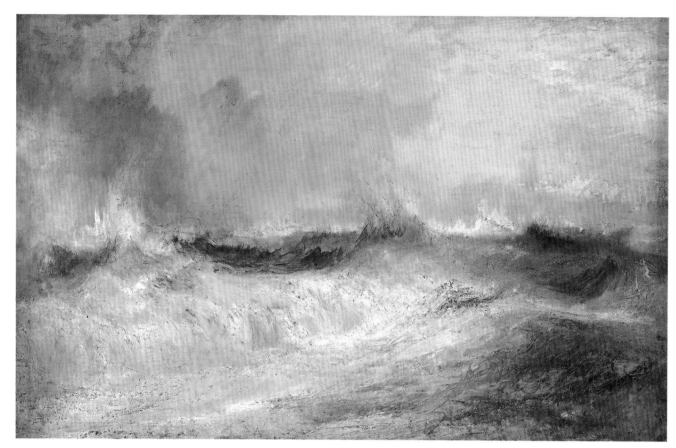

fig.67 'Waves Breaking
against the Wind' *c*.1835*

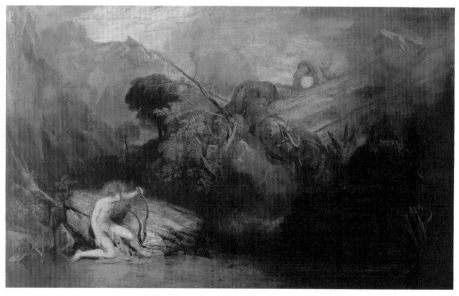

fig.68 'Apollo and Python'
exh.1811*

Turner used gamboge, Indian yellow, green lake and indigo in watercolours for most of his life, as did all his contemporaries. The indigo in particular has faded dramatically, leaving behind grey or red skies, when the paint was originally mixed from indigo and black, or indigo and vermilion, the latter to form an optical grey. These fugitive materials were more acceptable in watercolour medium. Turner was justly, though posthumously, criticised for using such 'vegetable colours' in oil. The colourmen who supplied such pigments can be largely exonerated from the charge of knowingly supplying Turner with pigments which would fade, for their concern over this issue was greater than Turner's.

Chrome yellows had a poor reputation in Turner's lifetime and later in the nineteenth century, but in fact they have survived remarkably well in his paintings, even in pale shades such as those found in 'The Arch of Constantine, Rome' (fig.69) and 'Norham Castle, Sunrise' (fig.70). Some of his pigment mixtures, such as emerald green with viridian, chrome yellow or Mars orange, madders and cochineal carmine with lead white, and Mars colours combined with most other pigments, have stood very well, and now present us with information on their lack of interactions, to counteract nineteenth-century beliefs that such mixtures were unstable. Turner did not employ 'safe practices' such as the protection of such pigments with varnish medium or varnish isolating layers. However, his habit of not grinding pigments finely may well have helped to preserve the colour of his paint: presenting a large surface area of finely ground pigment would have tended to promote interaction between pigment and other components of the paint.

fig.69 'The Arch of Constantine, Rome' c.1835*

Gelled paints were also known to be unstable, prone to cracking and darkening over the artist's lifetime, and to render the varnishing of such paint surfaces detrimental to their long-term stability. Such evidence was certainly accumulating during Turner's lifetime, but it must be borne in mind that the most sustained criticism of these media was made after his death, and that the earlier exhibited paintings which he sold with great ease were not necessarily available to him in later life for examination. The unsold ones which he kept in his studio or gallery were so badly affected by external agents such as dampness that he may not have been able to observe drying problems and the like properly. Turner's reasons for neglecting his paintings was that the impression he had sought to record was more important than the painting itself, and Ruskin wrote that 'He seemed not to care how they were injured, so that they were kept in the series which gave key to their meaning'.[2] Turner's experimental use of materials undoubtedly led to the distortion of many fine works, and ultimately engendered such concern over the stability of artists' materials that scientific studies were undertaken into the causes of fading and deterioration in the later nineteenth century.[3]

fig.70 'Norham Castle, Sunrise' c.1845*

EFFECTS OF CHOICE OF MATERIALS ON THE STABILITY OF OIL PAINTINGS

The absorbent grounds which Turner preferred have led to severe conservation problems, because Turner kept his canvases in extremely damp conditions in his studio, and allowed them to be spotted or flooded by rain. Some of these paintings were further damaged by Thames flood water in 1928. The conditions in Turner's studio encouraged mould to grow on the egg-based primings, which in turn led to early and brutal attempts to clean off the disfiguring spots left by mould, or wholesale repainting of affected areas. Damp storage conditions have also caused flaking of ground from canvas, and discolouration and embrittlement of the canvas, which made lining a necessity at a time when the process was little understood. (Traditional glue-lining involves protecting the paint surface, applying a water-based glue mixture to the back of the canvas when the painting is face down, laying on a new canvas to give support, and heating the glue to bond the canvases. The heating was done with heavy irons, and some areas of paint were heated and flattened more than others. Another treatment method involved moistening the paint and pressing it under a heavy weight.) The glue-lined paintings, some treated in the last century, are irrevocably altered in appearance and surface texture. Even those in private hands, being the paintings which escaped early from the rigours of Turner's studio, have nearly all been lined – the usual fate of works of that age. Unfortunately, the Brown primed canvases have not survived well. Nor have other lead/oil-primed nineteenth-century canvases. In consequence, most of them required lining at an early date too. The sketches, disregarded in the nineteenth century, often escaped glue lining altogether, and survive in better condition now. Stormy seas as seen in 'The Shipwreck' (fig.71) were painted with flecks of white megilped paint brushed on, and buttery oil paint

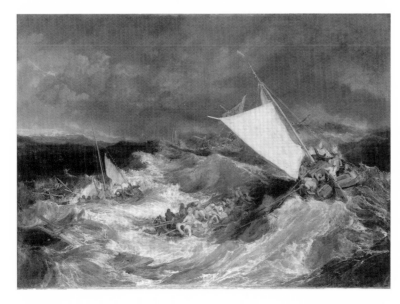

fig.71 'The Shipwreck'
exh.1805

applied with a palette knife, for the spray. These textured, impasted seas have suffered more from flattening during lining, and consequent darkening of the megilped medium when the reverse was ironed, than painted areas of calmer water, and the similarity in techniques for both is not obvious to the casual observer. Dark stormy seas may have a mid-toned wash for the earliest blocking-in of the composition, as landscapes do: sketches such as 'Shipping at the Mouth of the Thames' (see pp.28–9) certainly do. This would reduce their luminosity and exacerbate loss of contrast between opaque foam and transparent water, after lining damage has taken place.

Turner's habit of returning to sketches, and applying oil paint, megilp, or paint excessively thinned with an aromatic material such as turpentine over the old surface, without preparation or any regard for its stage of drying, has led to the problem of paint flaking from underlying paint in many works. Some of his paint formulations dried too quickly for safe use over the period needed to work up a large painting. The consequence is that most of his works have been and continue to be badly affected by any movement of the support caused by changes in temperature and relative humidity, and it is hazardous for them to travel and risk encountering such changes, or movement and vibration.

His regular use of wax/oil dispersions, and poorly mixed paint formulations including wax and other materials, have rendered the paintings of the 1820s and later, and especially the highly finished ones, temperature sensitive and unusually solvent-sensitive. Therefore, lining to treat other defects has sometimes caused the paint to melt and fuse, and has caused significant and irreversible darkening of bitumen-modified oil paint[4] and even of resin-modified paint. This makes deep shadows even darker, and destroys the tonal balance of the whole surface. Cleaning of the paint surface over the years has had damaging consequences such as the removal of glazes and scumbles. Some very wax-rich areas, already softened, have been unknowingly impregnated with wax/resin lining adhesive, which alters the surface appearance irreversibly, from transparent to opaque and milky, and kills Turner's deliberate contrast of matte and glossy surfaces. 'Sun Setting over a Lake' (Tate Gallery no4665) has suffered in this way. The unpredictable solvent sensitivity of such paint (because the surface varies so much in composition) makes removal of the varnish more difficult than it would be from paintings worked up with a different technique.

Turner's later technique of applying dry pigment in a thin layer of size to an oil painting, then varnishing over it, has not had any serious consequences. His use of excessively thinned paint which has contracted into little dots of underbound paint, or formed a matte, underbound film, has presented more problems. Such paint films are sensitive to abrasion, to loss of the paint medium (apparent as a lightening or 'blanching' of the surface), and to removal when the surface is cleaned with solvents and surfactants. The optical qualities of surfaces are severely altered by varnishing, too. Yet numerous examples of such survive. The problem can be identified and taken into account during conservation treatment.

AN EXAMPLE OF AN ALTERED PAINTING

There are all too many of Turner's oil paintings which have altered in several ways: one is 'View of Richmond Hill and Bridge' (figs.72–3). It is not known when it was lined, but it certainly was not in recent decades. The flattening caused by the process can be seen quite clearly. The surface has been overcleaned in the past too, though this is partially concealed now by a thick resinous varnish (not Turner's), which may have been tinted to a warm yellow. If it was not tinted, time and exposure to light have turned it a deep yellow. The varnish swamps surviving nuances of pink and blue scumble which are visible on microscopical examination of the yellow part of the sky. A contemporary critic wrote[5] that the painting

fig.72 'View of Richmond
Hill and Bridge' exh.1808*

fig.73 Detail of the sky of
'Richmond Hill'

was a wonderful representation of morning light: a judgement which the viewer could not make now. And the highly glazed shadows have deepened and darkened (though the thick varnish at least prevents them from scattering light and looking unsaturated) until the figures are receding into them. The figures may have sunk in as well, since they were painted over the landscape. Their reflections in the water have almost disappeared, eclipsed by yellow varnish and lost in decreased contrast due to the darkening of glazes, and possibly of the priming too. The yellow varnish obscures the once-lively reflections in the main part of the river; ageing cracks filled with dirt and old discoloured varnish detract from the light and glowing appearance of the bridge. Turner himself would surely have been saddened by the present appearance of his painting.

 Darkening of shadows can seriously reduce the legibility of the painting, even when there is no loss of colour. The middle distance tends to lose definition, and advances towards the viewer too strongly, while the trees lose modelling. Turner's Diploma work for the Royal Academy of Arts, 'Dolbadern Castle, North Wales' (fig.74) has darkened so much that the figures in the foreground are difficult to see: possibly he used a megilped paint in order to paint deep and glossy shadows.

fig.74 'Dolbadern Castle, North Wales' exh.1800

LITTLE-ALTERED PAINTINGS

Today one of the best-preserved of all Turner's oil paintings is 'Venice from the Canale della Guidecca, Chiesa di Santa Maria della Salute, &c.' exhibited in 1840 (fig.75). In 1893, it was considered to be in very poor condition, compared to the other four Turners in the Sheepshanks Bequest[6] at the Victoria and Albert Museum. Reports state that the surface was yellowed and that the cracks over most of the surface were disfiguring to the image. In that year, a glass-fronted case[7] was built to enclose the painting, a vacuum was created and the case was sealed. It has not been reopened since, though doubtless air has diffused in gradually, until the interior has reached atmospheric pressure. The painting has nonetheless been protected from dust, atmospheric pollutants, and the attentions of restorers after the initial treatment and glue-lining which preceded the sealing of the case. The painting now appears to be in excellent condition for any nineteenth-century work, especially when one examines the other Sheepshanks paintings, kept in common environmental conditions since 1892, by and large, except for the presence of air. 'Lifeboat and Manby Apparatus' (fig.76) can be used as a comparison. 'Venice' has very shallow hairline cracks over the surface, visible only in white areas at normal viewing distance, and the paint is scarcely deformed round

fig.75 'Venice from the Canale della Guidecca, Chiesa di Santa Maria della Salute &c.' exh.1840

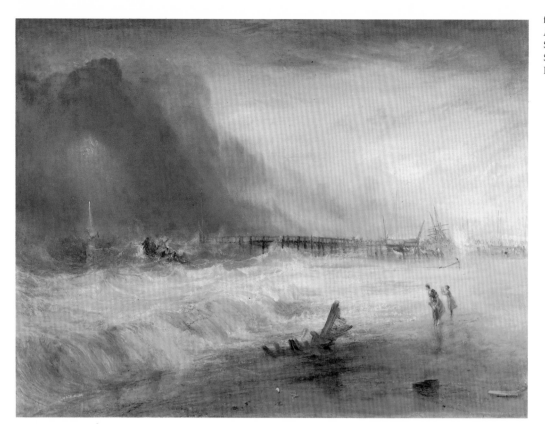

fig.76 'Lifeboat and Manby Apparatus Going off to a Stranded Vessel Making Signal (Blue Light) of Distress' exh.1831

the cracks, and is well-adhered to the canvas, so far as one can judge through glass. 'Manby Apparatus', exhibited ten years earlier, has wider cracks made more obvious by the accumulation of a dark yellow varnish in them. Even without the varnish, one could not now imagine it glowing as 'Venice' does. The buildings in 'Venice' are of a dazzling whiteness which few modern viewers would associate with the lead white pigment found in other, varnished, paintings by Turner. The reflections of the water in them can be seen as localised, pale yellow areas of glaze, easily distinguishable from the unglazed portions. The glazes have probably yellowed slightly nonetheless. The water is shot through with green, blue, and shadowy pinkish tones, whose gradations can be appreciated even at normal viewing distance. The water in 'Manby Apparatus' is stormy, and is seen by night, but it is very obvious that such delicate gradations of colour in that painting would be swamped by yellow varnish, darkening of the medium under the varnish, and decreased luminosity of the white priming. As a result of a preventive conservation measure, 'Venice' is now in excellent condition, and closer to its original appearance, than other paintings once considered to have survived better.

There is an obvious implication, though, that we are seeing a painting which viewers in 1893 might have seen when first exhibited – and they would presumably have thought that it had lost a great deal in fifty years. All the paintings exhibited at the Royal Academy, which is to say all the highly finished works, are considerably altered in appearance. Sympathetic cleaning can sometimes bring

back much of their original appearance, fortunately, provided that the work has not already been damaged. Some works outside the Turner Bequest have survived in good condition, with few cracks in highly finished areas.

In all too many cases, ageing and darkening of the medium, and the formation of surface cracks, have caused the worst changes in appearance and tonality. It is necessary to examine unfinished paintings or oils on paper in order to see surfaces which are close to Turner's original intentions. The Devon oil sketches on paper[8] serve as good examples because they have never been varnished. The unfinished paintings from the 1830s also approach them closely, since scumbles predominate in the works of that decade. 'The Arch of Constantine, Rome' (fig.69 on p.69) is a good illustration of a little-altered painting. The foliage retains a green tonality and a slightly unsaturated appearance, and the sky, though cracked through age, does not have islands of paint outlined by dark varnish, as happens in many works with wide drying cracks. Interestingly, there is evidence from cross-sections for 'oiling-out' layers over the ground and between some paint layers. This practice was recommended[9] by some nineteenth-century writers of artists' manuals to make the later application of wet paint possible, or at least easier. Such layers are absent from the greater number of Turner's works which were examined. Brush and palette knife work, and marks made by the handle of the brush are clearly visible. Twentieth-century critics[10] have bemoaned the loss of excellent ideas under too much finish, but in this exceptional case, the idea has survived well. Sadly, in most other cases, Ruskin's remarks on the alteration of Turner's painting, though perhaps overstated at the time, are now all too apt:

> The fates by which Turner's later pictures perish are as various as they are cruel; and the greater number, whatever care be taken of them, fade into strange consumption and pallid shadowing of their former selves. Their effects were either attained by so light glazing of one colour over another, that the upper colour, in a year or two, sank entirely into its ground, and was seen no more; or else, by the stirring or kneading together of colours chemically discordant, which gathered into angry spots; or else, by laying on liquid tints with too much vehicle in them, which cracked as they dried; or solid tints, with too little vehicle in them, which dried into powder and fell off; or painting the whole on an ill-prepared canvas, from which the picture peeled like the bark of a birch-tree; or using a wrong white, which turned black, or a wrong red, which turned grey, or a wrong yellow, which turned brown. But, one way or another, all but eight or ten of his later pictures have gone to pieces, or worse than pieces – ghosts, which are supposed to be representations of their living presence.[11]

CHAPTER 6

Recent discoveries about Turner's use of materials

Detailed studies of the 'Wallhalla'[1] revealed that the white paint at different areas varied in medium composition from a very lean linseed oil paint with some added protein to a linseed oil medium further enriched with spermaceti wax, beeswax and triterpenoid resins (such as mastic), while the glaze samples were linseed oil and mastic resin mixtures consistent with the megilps discussed in chapter 3, but tending to be resin-rich. Proteinaceous materials added to oil paint also gave new and desirable textures: Constable mixed egg and linseed oil for crisply impasted clouds on at least one occasion.[2] Turner may have mixed oil/wax formulations as found in limp-looking impasto for clouds and other distant subjects with oil/resin megilps already present on his palette, to obtain paint with the desired appearance or handling characteristics. Mixtures of beeswax and spermaceti wax have since been found in other nineteenth-century paintings.[3]

Analysis of paint from the early 'Dolbadern Castle' (fig.74) confirmed that Turner used driers with the oil, and a comparison with laboratory-made samples suggests that his drier was lead acetate[4]. Several important late Turner oils have been examined and analysed recently: 'The Dawn of Christianity – the Flight into Egypt' (exhibited 1841, now in the Ulster Museum)[5], 'Snowstorm – Steam-boat off a Harbour's Mouth' (exhibited 1842, now at the Tate)[6], 'Van Tromp, going about to please his Masters' (exhibited 1844, now in the J. Paul Getty Museum)[7]. All of them proved to be as complex as the 'Wallhalla', discussed in chapter 4. Spermaceti wax was found[8] in 'The Dawn of Christianity', and samples of pure megilp, where Turner marked out the canvas for an octagonal, then later a circular frame, and used the corners to try out paint. The megilp samples here are thick, and of a deep honey-colour now. They have no pigment in them, since they would normally have been mixed into paint on the palette, or else used as a golden-toned glaze to add local warmth. Similar-looking resin-rich megilped glazes can be seen on the well-preserved surface of 'Van Tromp', now more yellow than when Turner first applied them, but still giving beauty to the sea. The sky of 'Van Tromp' much resembles that of the 'Wallhalla': in the latter painting detailed analysis showed that now-cracked and well-preserved areas actually had the same constituents, in different proportions.[9] Some proportions of pigment and mixed medium crack rapidly, while others remain unaltered for a longer time before they may eventually crack too. 'Snowstorm' shows the same effects, and also the very wide cracks long attributed to bitumen in the paint formulation, but which could equal-

ly be attributed to synthetic bitumen or other non-drying materials, in our present state of knowledge.[10] 'The Fighting Temeraire' of 1838, an exceptionally well-preserved painting, has been discussed recently[11]: it proved to have a medium of walnut oil, some of it pre-polymerised, and fewer examples of modified oil medium than many other late oils, which accounts for its good condition today. It also has glazes which may have included gum benzoin.

Several more of the pigments left in Turner's studio have been found in recently-examined works: iodine scarlet in the 'Temeraire'[12], Naples yellow in 'Dolbadern Castle', chalk in the gouache of 'A Stormy Coast'[13], and barytes and magnesium carbonate in the gouache of 'Mont Pilatus from Lake Lucerne'[14]. The 'Temeraire' provides an early example of the use of barium chromate, and an even earlier use has been reported, in 1829 in 'Ulysses deriding Polyphemus'.[15] Once more, Turner's ready use of new materials is forcing us to revise our ideas on earliest dates of production. It is still not known if Turner had access to cadmium yellows or zinc chromate, and to date they have not been discovered in his paintings.

A study of Turner's drawings, touched etchings and final prints for the 'Liber Studiorum' has just been completed.[16] All the techniques described in chapter 1, under painting in watercolour medium, could be seen in these early works, used with great assurance whenever a particular highlight or contrast was needed. Indeed, it appears that Turner applied processes used in etching, such as stopping-out, scratching out areas for highlights, and the use of fine etching needles and rockers to give new textural effects to watercolour wash applied to paper. As ever, he never forgot the means used to achieve an interesting effect, and he could easily use the method years later, sometimes in a different medium as well.

NOTES

Introduction

1 W. Thornbury, *The Life and Correspondence of J.M.W. Turner R.A.*, reprinted 1970
2 Ibid.
3 C. Price, 'Turner at the Pantheon Opera House 1791–2', *Turner Studies*, vol.7, no.2, 1987, pp.2–8
4 A. Wilton, *Painting and Poetry; Turner's 'Verse Book' and his Work of 1804–12*, exh. cat., Tate Gallery 1990; D.B. Brown, *Turner and Byron*, exh. cat., Tate Gallery 1992
5 A. Wilton, *The Life and Work of J.M.W. Turner*, 1979; A. Wilton, 'The Keepsake Convention: Jessica and Some Related Pictures', *Turner Studies*, vol.9, no.2, 1989, pp.14–35
6 *The Works of John Ruskin*, ed. E.T. Cook and A. Wedderburn, *Modern Painters*, vols.III–VII and *The Stones of Venice*, vols.IX–XI, 1903
7 Thornbury 1970
8 A.J. Finberg, *The Life of J.M.W. Turner R.A.*, 2nd ed., Oxford 1961
9 Wilton 1979; A. Wilton, exhibition review, *Turner Studies*, vol.5, no.1, 1985, pp.53–4; A. Wilton, *Turner Watercolours in the Clore Gallery*, 1987; M. Butlin, in J. Gage (ed.), *Turner 1775–1851*, 1974, pp.175–97; A. Lyles, *Turner and Natural History: The Farnley Project*, exh. cat., Tate Gallery 1988
10 N.W. Hanson, 'Some Recent Developments in the Analysis of Paints and Painting Materials', *Official Digest*, vol.328, 1953, pp.163–74; N.W. Hanson, 'Some Painting Materials of J.M.W. Turner', *Studies in Conservation*, no.1, 1954, pp.162–73
11 W. Hardy, *The History and Techniques of the Great Masters: Turner*, 1988
12 J.H. Townsend, 'The Materials of J.M.W. Turner: pigments' *Studies in Conservation* vol.38, 1993, pp.231–254; J.H. Townsend, 'The materials of J.M.W. Turner: primings and supports', *Studies in Conservation* vol.39, 1994, pp.145–153; J.H. Townsend, 'Microscopy and paintings', *Microscopy and Analysis* vol.39, January 1994, pp.11–13; J.H. Townsend, 'Painting techniques and materials of Turner and other British artists 1775–1875', *Historical Painting Techniques, Materials And Studio Practice*, preprints, Getty Conservation Institute, (1995) pp.176–186; J.H. Townsend (ed.) *Turner's Painting Techniques in Context*, postprints, United Kingdom Institute for Conservation, 1995
13 J.H. Townsend, Picture Note, 'Two Women and a Letter', *Turner Studies*, vol.9, no.2, 1989, pp.11–13; J.H. Townsend, Picture Note, '"Judith with the Head of Holofernes" by J.M.W. Turner and C.L. Eastlake', *Turner Studies*, vol.9, no.2, 1989, pp.34–5; A. Wilton, Picture Note, 'Study for the Sack of a Great House?', *Turner Studies* vol.10 no.2, 1990, pp.55–9; J.H. Townsend and I. Warrell, Picture Note, 'Figures in a Building', *Turner Studies*, vol.11, no.1, 1991, pp.54–7

Chapter 1

1 M. Butlin and E. Joll, *The Paintings of J.M.W. Turner*, 2 vols., 2nd. ed., 1984; Wilton 1990; Brown 1992
2 R. Jones, 'The Artist's Training and Techniques', in *Manners and Morals*, exh. cat., Tate Gallery 1987, pp.19–29
3 S. Cove, 'Constable's Oil Painting Materials and Techniques', in *Constable*, exh. cat., Tate Gallery 1991, pp.493–518
4 J. Gage, *A Wonderful Range of Mind*, 1987
5 The 'Carthage' paintings, B&J 429–32
6 Thornbury 1970, p.352
7 Ibid., p.365
8 Ibid., p.363
9 M. Butlin, M. Luther and I. Warrell, *Turner at Petworth: Painter and Patron*, exh. cat., Tate Gallery 1989, pls. 46, 49, 50, of TB CCXLIV 103, 102, 120 respectively
10 'George IV's Departure from the "Royal George", 1822' (fig.48)
11 J. Gage, *Colour in Turner, Poetry and Truth*, 1969
12 P. Bower, *Turner's Papers: A Study of the Manufacture, Selection and Use of his Drawing Papers 1787–1820*, exh. cat., Tate Gallery 1990; P. Bower, 'Information Loss and Image Distortion Resulting from the Handling, Storage and Treatment of Sketchbooks and Drawings', Conference Papers, The Institute of Paper Conservation, 1992, pp.61–7
13 L.A. Carlyle, 'A Critical Analysis of Artists' Handbooks, Manuals, and Treatises on Oil Painting Published in Britain from 1800 to 1900: with Reference to Selected Eighteenth Century Sources', unpublished doctoral research, Courtauld Institute of Art, University of London 1991. The examination of cross-sections at the Tate Gallery has shown that the majority of nineteenth-century panel supports were supplied ready-primed.
14 Carlyle 1991
15 I. Bristow, personal communication to A. Southall when she was conserving the painting.
16 A. Wilton, *Turner in his Time*, 1987, pp.248–9
17 'Lucy, Countess of Carlisle' (Tate Gallery N00515) and 'Watteau Study by Fresnoy's Rules' (Tate Gallery N00514)
18 B&J 338, 340
19 Townsend and Warrell 1991, pp.54–7
20 R. Jones, 'Notes for conservators on Wright of Derby's Technique and Studio Practice', *The Conservator*, no.15, 1991, pp.13–32; Carlyle 1991 quoting C. Hayter, *An Introduction to Perspective ... A Compendium of Genuine Instruction in the Art of Drawing and Painting ...*, 2nd ed., 1815, p.56, Anon., *A Compendium of Colours, and Other Materials Used in the Arts ...*, 1808, p.66, and F. Oughton, *Students and Amateurs Notebook on Oil Colour Technique Etc.*, 1892, p.9
21 J. Gage, *The Collected Correspondence of J.M.W. Turner*, 1980, letter no.140
22 B&J 177–93
23 Cove 1991
24 Carlyle 1991
25 J. Cawse, *The Art of Painting Portraits, Landscapes, Animals, Draperies, Satins, etc, in Oil Colours: Practically Explained by Coloured Palettes ...*, 1840
26 Jones 1991
27 *The Diary of Joseph Farington*, ed. K. Garlick and A. MacIntyre (vols.I–VI), London and New Haven, 1978, II, p.216, for 1804
28 Ibid.
29 A.J. Finberg, *A Complete Inventory of the Drawings in the Turner Bequest*, 1909
30 Farington I, p.273, for 1799
31 Thornbury 1970, p.516
32 See n.29.
33 R. Jones, 'Wright of Derby's Techniques of Painting', in *Wright of Derby*, exh. cat., Tate Gallery 1990, pp.263–72
34 Thornbury 1970, p.362
35 Ruskin VII 1903, pp.247–8
36 A. Wilton, *Turner Watercolours in the Clore Gallery*, 1987; Finberg 1961
37 Gage 1969; J. Gage, 'Turner's Annotated Books: Goethe's Theory of Colours', *Turner Studies*, vol.4, no.2, 1984, pp.34–52
38 Ibid.
39 f.24 of sketchbook, as discussed by Finberg 1961, p.183
40 f.33 of sketchbook, as discussed by Finberg 1961, p.186
41 M. Kemp, *The Science of Art: Optical Themes in Western Art from Brunelleschi to Seurat*, New Haven and London 1990
42 A. Wilton, personal communication
43 M.E. Chevreul, *De la loi du contraste simultane des couleurs*, France, 1839
44 Thornbury 1970
45 B&J 427

Chapter 2

1 Carlyle 1991
2 G. Field, *Chromatics*, 1817
3 Thornbury 1970, p.227
4 G. Field, *Chromatography or, A Treatise on Colours and Pigments and of their Powers in Painting &c*, 1835
5 Thornbury 1970, p.124
6 P. Bower, 'The Fugitive Mr. Turner', *Turner Society News*, no.53, 1989, p.5
7 D. Bomford, J. Kirby, J. Leighton and A. Roy, *Art in the Making: Impressionism*, National Gallery 1990, p.66
8 R.D. Harley, *Artists' Pigments c.1600–1835: A Study in English Documentary Sources*, 2nd. ed., 1982, p.101
9 Bomford et al. 1990, p.58
10 Harley 1982, p.58
11 Ibid. p.179
12 Bomford et al. 1990, p.61
13 D. Saunders and J. Kirby, personal communication
14 Field 1835
15 Carlyle 1991
16 Gage 1969
17 R.D. Harley, 'Some New Watercolours in the Nineteenth Century', *The Conservator*, no.11, 1987, pp.46–50; R.J. Gettens and G.L. Stout, *Painting Materials: A Short Encyclopaedia*, 1966
18 Analysed by Ashok Roy
19 Analysed by Ashok Roy
20 Harley 1982, p.179
21 Ruskin XIII 1903, p.451
22 N.W. Hanson, 'Some Painting Materials of J.M.W. Turner', *Studies in Conservation*, no.1, 1954, pp.162–73
23 J.H. Townsend, 'Turner's Writings on Chemistry and Artists' Materials', *Turner Society News*, no.62, 1992, pp.6–10
24 D.B. Brown, *Noble and Patriotic: The Beaumont Gift, 1828*, exh. cat., National Gallery 1988, p.25
25 Thornbury 1970, p.363
26 Ruskin III 1903, p.293
27 Field 1835; R.D. Harley, 'Field's Manuscripts: Early Nineteenth-Century Colour Samples and Fading Tests', *Studies in Conservation*, no.24, 1979, pp.75–84
28 Thornbury 1970, p.124
29 C. Martel, *On the Materials Used in Painting, with a Few Remarks on Varnishing and Cleaning Pictures* 1859
30 Thornbury 1970, p.124

Chapter 3

1 Carlyle 1991
2 Cove 1991
3 R. White and J. Pilc, 'Analyses of Paint Media', *National Gallery Technical Bulletin*, no.14, 1993, pp.86–94
4 J.H. Townsend, 'The Refractive Index of Nineteenth Century Paint Media: A Preliminary Study', *ICOM Committee for Conservation Pre-prints*, 1993, vol.II, pp.586–591
5 L.A. Carlyle and A. Southall, 'No Short Mechanic Road to Fame: The Implications of Certain Artists' Materials for the Durability of British Painting 1770–1840', in *Robert Vernon's Gift: British Art for the Nation 1847*, exh. cat., Tate Gallery 1993, pp.21–6
6 Ibid
7 J.C. Ibbetson, *An Accidence or Gamut, Of Painting in Oil and Watercolours*, 1, 1803
8 Carlyle and Southall 1993
9 Gas chromatography carried out by Jennifer Pilc revealed the presence of beeswax, and research is continuing with Jaap Boon, on the characterisation of paint from the 'Wallhalla'; see chapter 6 and its notes
10 Carlyle 1991
11 Cove 1991
12 Carlyle 1991
13 Thornbury 1970, p.365
14 Ibid., p.364
15 Ruskin, XXXV 1903, letter 6
16 Thornbury 1970, p.238
17 Extract from *Catalogue of the British Fine Art Collection at South Kensington*, quoted in the conservation records at the Victoria and Albert Museum, for Turner oil paintings in the Sheepshanks Bequest; Gage 1987, pp.93–4
18 Butlin and Joll 1984

Chapter 4

1 B&J 68
2 Townsend 1993, see chapter 3 note 4
3 B&J 401
4 Thornbury 1970, p.175
5 L.A. Carlyle, 'British Nineteenth Century Oil Painting Instruction Books: A Survey of their Recommendations for Vehicles, Varnishes and Methods of Paint Application', *Cleaning, Retouching and Coatings*, 1990, pp.76–80
6 Carlyle 1990
7 Carlyle 1991
8 Thornbury 1970

Chapter 5

1 Ruskin VII 1903, p.409
2 Thornbury 1970, p.304
3 W.J. Russell and W. de W. Abney, *Action of Light on Watercolours*, Report to the Science and Art Department of the Committee of Council on Education 1888
4 J.H. Townsend, Turner's use of materials, and implications for conservation', *Turner's Painting Techniques In Context*, UKIC, 1995, pp.5–11
5 B&J 73
6 L. Herrmann, book review, *Turner Studies*, vol.10, no.2, 1990, p.52
7 British patent no. 6556, 1892; S. Edmunds, 'A Microclimate Box for a Panel Painting Fitted within a Frame', *Conservation Today*, 1988, pp.50–3
8 D.B. Brown, *Oil Sketches from Nature*, exh. cat., Tate Gallery 1991
9 Carlyle 1990
10 Gage 1969
11 B&J 342

Chapter 6

1 J.J. Boon, J. Pureveen, D. Rainford and J.H. Townsend, '"The Opening Of The Wallhalla, 1842": Studies On The Molecular Signature Of J.M.W. Turner's Paint By Direct Temperature-Resolved Mass Spectrometry (DTMS)', *Turner's Painting Techniques In Context*, post-prints, UKIC, ed. J.H. Townsend, 1995, pp.35–45
2 Cove 1991, p.503
3 J. Boon, *pers. comm.*
4 D. Rainford, *pers. comm.*
5 B&J 394
6 B&J 398
7 B&J 410
8 Tom Learner. Tate Gallery report
9 Marianne Odlyha, *pers. comm.*
10 See chapter 3 note 5
11 J.Egerton, *Making and Meaning: Turner. The Fighting Temeraire*, National Gallery Publications, London, 1995
12 See 11
13 TB CCLXIII 143 of *c.*1830
14 TB CCCXXXII 26 of *c.*1845
15 M.Wyld and A. Roy, in *The Fighting Temeraire*, pp.121–123, B&J 330
16 G. Forrester, *Turner's 'Drawing Book': The Liber Studiorum*, Tate Publishing, 1996

List of Works Illustrated

All works are by J.M.W. Turner, and all are in the Turner Bequest unless otherwise stated. Measurements are given in centimetres, height before width. Works shown in the exhibition are marked with an asterisk.

1 S.W. PARROTT
'Turner on Varnishing Day' c.1846
Oil on canvas 25.1 × 22.9 ($9^{7}/_{8}$ × 9)
Ruskin Gallery, Collection of the Guild of St George

2 J.M.W. Turner's box of oil paints and pigments, found in his studio after his death
Tate Gallery Archive 7315.6

3 One of J.M.W. Turner's watercolour palettes
Visitors of the Ashmolean Museum, Oxford

4 *Smaller South Wales* sketchbook
'Penilyne Castle' 1795
Pencil on paper 13.2 × 20.6 ($5^{1}/_{4}$ × $8^{1}/_{8}$)
TB XXV 7
D00468

5 Reverse of 'George IV's Departure from the "Royal George", 1822'
(see no.48)

6 *Studies near Brighton* sketchbook
'Study of Pigs'* 1796
Watercolour on paper 11 × 12.9
($4^{3}/_{8}$ × $5^{1}/_{8}$)
TB XXX 93
D00838

7 'Village with Cloud'* 1802
Pencil on grey-washed paper 22 × 28.3
($8^{5}/_{8}$ × $11^{1}/_{8}$)
TB LXXIV 58
D04551

8 'Sprigs' used to fasten canvas to the stretcher of 'The Vision of Medea'
(see no.46)

9 'Morning amongst the Coniston Fells, Cumberland'* exh.1798
Oil on canvas 122.9 × 89.9
($48^{3}/_{8}$ × $35^{3}/_{8}$)
B&J 5
N00461

10 Cross-section from the grey sky of 'Morning amongst the Coniston Fells'

11 'Field of Waterloo: 1815' exh.1818
Oil on canvas 147.5 × 239 ($58^{1}/_{8}$ × $94^{1}/_{8}$)
B&J 138
N00500

12 'Radley Hall: South Front and East Side'* 1789
Watercolour on paper 33 × 51
(13 × $20^{1}/_{8}$)
TB III D
D00049

13 'Thames River Scene'* c.1805
Watercolour on paper 26 × 36.5
($10^{1}/_{4}$ × $14^{3}/_{8}$)
TB XCV 47
D05951

14 'Pembury Mill, Kent'* c.1806–7
Watercolour on paper 18.1 × 25.2
($7^{1}/_{8}$ × $9^{7}/_{8}$)
TB CXVI O
D08116

15 Detail of 'Thames River Scene'

16 'Vale of Pickering, Yorkshire, with Huntsmen'* ?c.1815
Watercolour on paper 19.2 × 24.4
($7^{1}/_{2}$ × $9^{5}/_{8}$)
TB CXXI Q
D08273

17 'Coniston Old Man (?)' 1799–1800
Watercolour on paper 67 × 85
($26^{3}/_{8}$ × $33^{1}/_{2}$)
TB XXXVI U
D01115

18 'Mont Blanc from Brévant (?)' c.1836
Watercolour on paper 24.5 × 30.6
($9^{5}/_{8}$ × 12)
TB CCCLXIV 93
D35936

19 'Scarborough' c.1809
Watercolour on paper 67.6 × 101
($26^{5}/_{8}$ × $39^{3}/_{4}$)
TB CXCVI C
D17167

20 'The Rigi, Last Rays' c.1842
Watercolour on paper 24.9 × 37.1
($9^{3}/_{4}$ × $14^{5}/_{8}$)
TB CCCLXIV 219
D36065

21 'Shipping at the Mouth of the Thames'* c.1806–7
Unfinished oil on canvas
85.7 × 116.8 ($33^{3}/_{4}$ × 46)
B&J 175
N02702

22 'Goring Mill and Church'* c.1806–7
Unfinished oil on canvas
85.7 × 116.2 ($33^{3}/_{4}$ × $45^{3}/_{4}$)
B&J 161
N02704

23 'Richmond Hill with Girls Carrying Corn' c.1819
Unfinished oil on canvas 147 × 238
($57^{7}/_{8}$ × $93^{3}/_{4}$)
B&J 227
N05546

24 'Rocky Bay with Figures'* c.1830
Oil on canvas 90.2 × 123.2
($35^{1}/_{2}$ × $48^{1}/_{2}$)
B&J 434
N01989

25 'Story of Apollo and Daphne'* exh.1837
Oil on panel 109.9 × 198.8
($43^{1}/_{4}$ × $78^{1}/_{4}$)
B&J 369
N00520

26 Detail of the upper right of 'Apollo and Daphne'

27 'A River Seen from a Hill'* c.1840–5
Unfinished oil on canvas 78.7 × 79.4
(31 × $31^{1}/_{4}$)
B&J 532
N05475

28 'A Lady in Van Dyck Costume' c.1830–5
Oil on canvas 121 × 91 ($47^{5}/_{8}$ × $35^{7}/_{8}$)
B&J 444
N05511

63 X-radiograph of the same area of the foreground of the 'Wallhalla'

64 'Peace – Burial at Sea'* 1841, exh.1842
Oil on canvas 87 × 86.7 (34$^{1}/_{4}$ × 34$^{1}/_{8}$)
B&J 399
N00528

65 Detail of the sky of 'Peace – Burial at Sea'

66 'Rosenau' c.1841–2
Oil on canvas 96.5 × 124.5 (38 × 49)
Trustees of the National Museums and Galleries on Merseyside (Walker Art Gallery, Liverpool)
B&J 442

67 'Waves Breaking against the Wind'*
c.1835
Unfinished oil on canvas 58.4 × 88.9 (23 × 35)
B&J 457
N02881

68 'Apollo and Python'* exh.1811
Oil on canvas 145.4 × 237.5 (57$^{1}/_{4}$ × 93$^{1}/_{2}$)
B&J 115
N00488

69 'The Arch of Constantine, Rome'*
c.1835
Unfinished oil on canvas 91.4 × 121.9 (36 × 48)
B&J 438
N02066

70 'Norham Castle, Sunrise'* c.1845
Oil on canvas 90.8 × 121.9 (35$^{3}/_{4}$ × 48)
B&J 438
N01981

71 'The Shipwreck' exh.1805
Oil on canvas 170.5 × 241.5 (67$^{1}/_{8}$ × 95)
B&J 54
N00476

72 'View of Richmond Hill and Bridge'*
exh.1808
Oil on canvas 91.4 × 121.9 (36 × 48)
B&J 73
N00557

73 Detail of the sky of 'Richmond Hill'

74 'Dolbadern Castle, North Wales'
exh.1800
Oil on canvas 119.5 × 90.2 (47 × 35$^{1}/_{2}$)
Royal Academy of Arts
B&J 12

75 'Venice from the Canale della Guidecca, Chiesa di Santa Maria della Salute &c.' exh.1840
Oil on canvas 61 × 91.4 (24 × 36)
Board of Trustees of the Victoria and Albert Museum
B&J 384

76 'Lifeboat and Manby Apparatus Going off to a Stranded Vessel making Signal (Blue Light) of Distress' exh.1831
Oil on canvas 91.4 × 122 (36 × 48)
Board of Trustees of the Victoria and Albert Museum
B&J 336